PRACTICAL
ART
SCHOOL

PRACTICAL DRAWING WITH
PASTELS

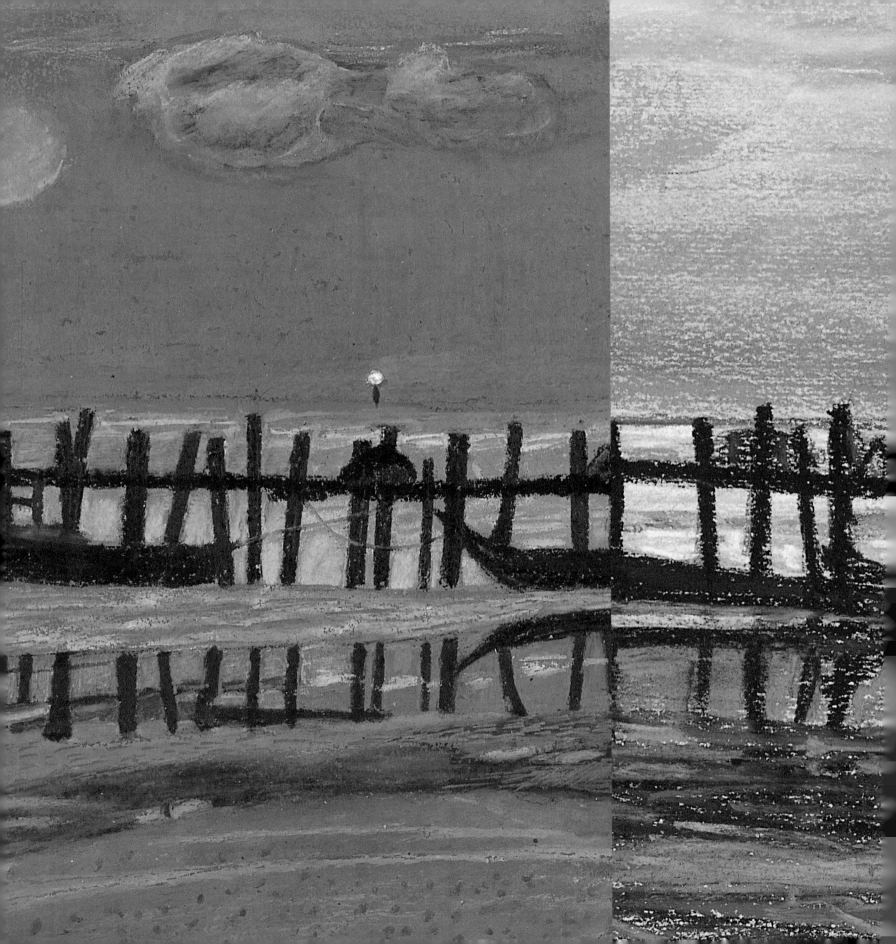

PRACTICAL DRAWING WITH
PASTELS
GERALD WOODS

The Comprehensive Guide to
Materials and Techniques

COURAGE
BOOKS

AN IMPRINT OF RUNNING PRESS
PHILADELPHIA · LONDON

CLB 4342

9 8 7 6 5 4 3 2 1
Digit on the right indicates the number of this printing.

Library of Congress Cataloging-in-Publication Number 95–70136

ISBN 1–56138–597–2

This book was designed and created by The Bridgewater Book Company Ltd
Designed by Peter Bridgewater/Annie Moss
Edited by Viv Croot
Managing Editor Anna Clarkson
Photography by Jeremy Thomas
Typesetting by Vanessa Good/Kirsty Wall

Color separation by Scantrans PTE Ltd, Singapore
Printed and bound in Spain by Graficas Estella

Published by Courage Books,
an imprint of Running Press Book Publishers
125 South Twenty-second Street
Philadelphia, PA 19103-4399

Contents

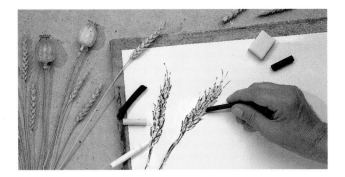

At-a-Glance Guide

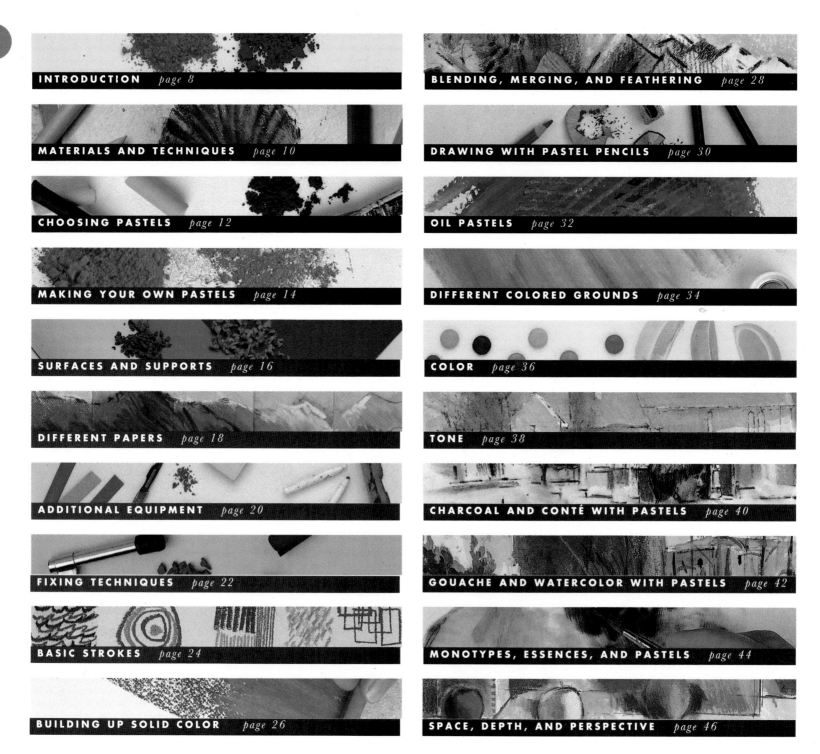

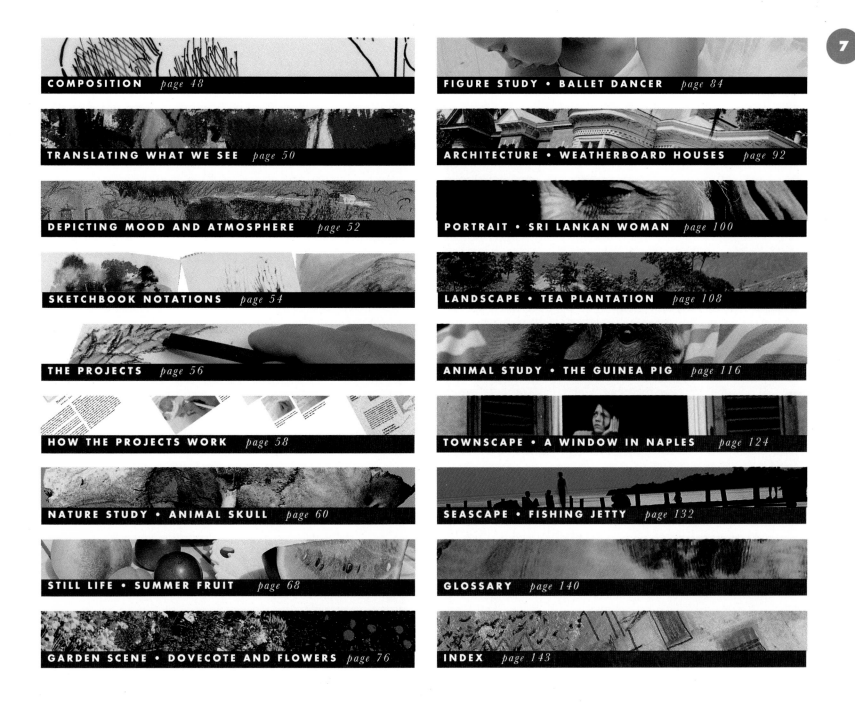

Introduction

It is a curious fact that we owe the unique development of pastel technique to the failing eyesight of the painter Edgar Degas. As the constraints of fine brushwork gradually eluded him, Degas turned his attention to the broader and more direct technique of soft chalk pastels. He eventually found a way of using the medium with great fluency, accentuating and concealing at one and the same time the plastic movement of the human form in his prolific studies of dancers. In a sense, Degas liberated the medium by exploiting the cumulative strokes of raw pigment. In describing Degas's portrait of Durante, the critic J. K. Huysmans gave an illuminating insight into the artist's technique:

"The almost bright pink patches on the forehead, the green on the beard, the blue on the velvet of the sitter's collar; whilst the fingers are made up of yellow edged with bishop's violet. Near to, it consists of a hatching of colours which are hammered out and split up and appear to encroach one on the other; but at a few paces everything is in harmony and melts into the exact flesh tone."

Degas's pastels bear the imprint of his supreme gift as a draftsman, but those passages which are burnished and blended produce an effect which is virtually a form of painting. It is, however, the directness of the medium which makes it particularly appealing to those artists who work directly from observation – a broad range of color and tone can be established quickly and the work completed in a single session.

To work confidently with pastels one needs to have some basic understanding of color contrasts and harmony. When asked, "But how did you manage to get such vivid color in those dancers? They are as brilliant as flowers," Degas responded by saying, "With the neutral tone, *parbleu*."

The first part of the book is devoted to materials and techniques, including basic exercises designed to give the

beginner more control over the medium. Color, composition, and tone are explored in relation to the particular constraints of the medium. Mixed media techniques are included to demonstrate how the range of color and texture can be extended. The particular problems of working in pastel directly from observation – translating what we see, depicting mood and atmosphere, and sketchbook studies – are considered in relation to specific themes and subjects.

In the second part of the book, three artists have produced a series of ten projects, working in their own individual style, but using the same sources of reference. There is an introduction to each project, examining the specific problems posed by the diverse subjects. The development of the projects is revealed in step-by-step illustrations, offering a unique insight into the working methods of each artist. There follows a brief critique of the finished work, looking at salient points of achievement in terms of drawing, color, composition, and so on.

All art ultimately requires a physical act and none of the ideas propounded in this book will begin to make sense until that moment when, having opened your recently purchased box of pastels, your fingers become ingrained with pigment as you begin to construct the world you see around you in your own terms.

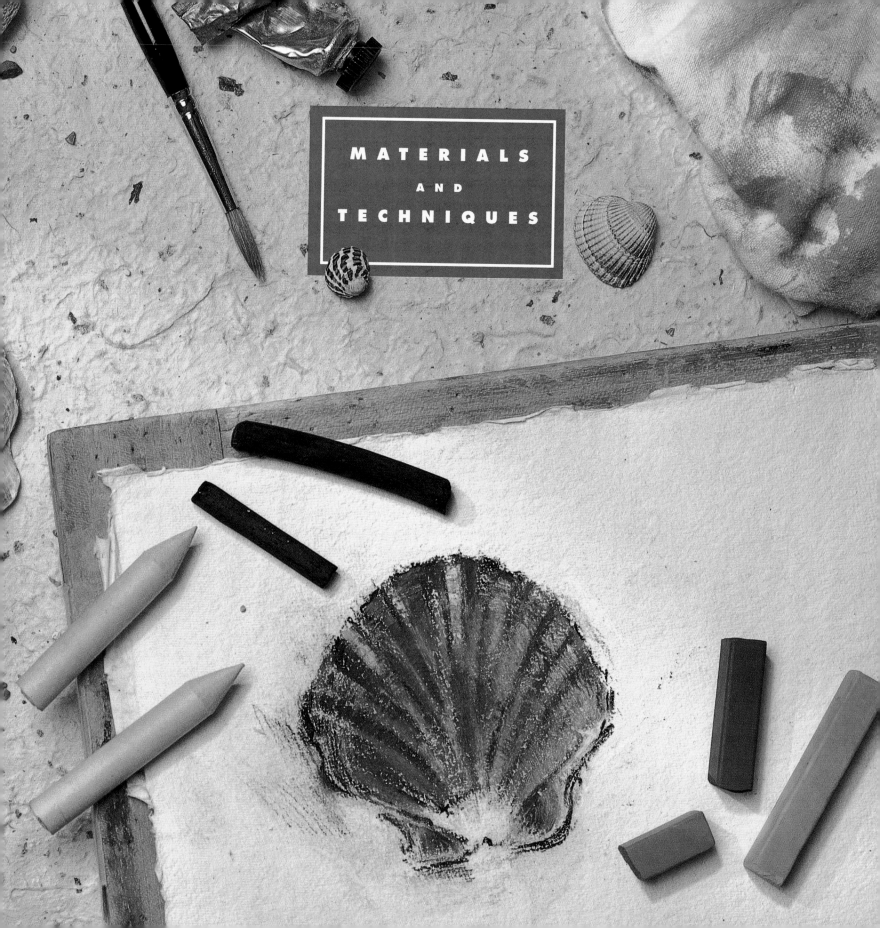

MATERIALS
AND
TECHNIQUES

Choosing Pastels

Soft pastels are quite simply sticks of molded pigment mixed to a binder to form a "paste." Generally, gum tragacanth is used as a binder but there are also a number of other equally suitable binding agents. The sticks are extremely fragile and are supported by an outer layer of tissue paper, which can be peeled back gradually as the work progresses.

One important advantage that pastels have over painting media such as oil and gouache is that, whereas paints can dry to either a lighter or darker tone, pastels do not undergo any such change.

The enormous color range available in pastels is made possible by reducing the stronger primary, secondary, and tertiary colors with a white base filler to produce an extensive sanicle of delicate tints. When selecting your own color palette, there are a number of points worth considering. Think about the kind of subjects to which you are drawn: landscapes, portraits, or flower studies, for instance. All require a basic range of colors, but you might need a number of neutral tints, in addition, to express light and shade. Your preferred subject may demand a dominant hue. Remember that almost every subtle nuance of color in your drawing will require a separate stick of pastel. It sometimes happens that a carefully placed color can provide a keynote to the entire work. The color and tone of the paper support that you choose will also influence the degree of brightness and contrast in the finished work.

The crumbly texture of soft pastels produces very different marks to those made with colored chalks or wax crayons. Used forcefully, a stick of soft pastel can be diminished rapidly, and the beginner might initially find them difficult to handle. The quality of soft pastels varies considerably; the less expensive ranges, for example, might be made from synthetic pigments and a high proportion of white filler.

Hard pastels contain a higher proportion of binder and are more tightly compressed. They produce a much sharper line and are used primarily for the initial structure when building up a pastel drawing. The pastels are sharpened either by breaking the stick, leaving a sharp point on each corner, or by wearing down one tip of the pastel on a pad

Soft pastels

Stiff brush

of sandpaper. The pigment deposited from hard pastels is less likely to be absorbed into the grain of the paper than soft pastel pigment and, as a consequence, is much easier to remove – preferably with a stiff painting brush.

Your initial palette might well consist of, say, six hard pastels – four primaries and a stick each of black and white – and 35 soft pastels, chosen individually rather than as a boxed set. Try to include a scale of warm and cool neutral tints in your selection, and include a few special colors such as Carmine Red or Olive Green. Ideally, you will need to have a light, middle, and dark tone of each color, which means that for a basic palette of 12 colors you will need 30 pastels. Manufacturers generally grade pastels according to the strength of each color. A permanent deep red, for instance, might be produced as a pale tint in No. 1 grade and a more intense shade in No. 10 grade. Some manufacturers prefer to denote the amount of white filler used in reduction in percentage decimal points. Confronted by a huge range of colors in an art store, however, I tend to select by sight – or rather, the colors select me!

PASTEL PENCILS

Pastel pencils are used when finer detail is required, since they can be sharpened to a fine point. They have the advantage of being protected by the outer wood casing, which helps to prevent breaks. If you are used to drawing with a pencil, you might be tempted to use them alone, not in conjunction with sticks of soft pastel. This would be a mistake, in my view, since you would never be able to experience the freedom of expression that comes from the broader application of colored pigment.

OIL PASTELS

Oil pastels are a comparatively recent addition to pastel technique. The main difference is that they require an oil-based binder. With their consequent high grease content, the drawn strokes from oil pastels are less granular, but more transparent, than those made by soft chalk pastels. The colors are generally stronger, more intense, and darker in tone. They should not be used in conjunction with chalk pastels because of their mutual antipathy. Once deposited on the paper support, oil pastels can be further diluted with white spirit to produce a colored glaze effect.

Oil pastels

White spirit

Pastel pencils

Making Your Own Pastels

14

Although one is spoiled for choice when it comes to purchasing pastels in an art store, the fact is that they are quite simple to make at home – and much less expensive. The whole process of blending and binding pigment yourself can enhance your understanding of color values. Another advantage of making your own pastels is that you can shape them individually – large or small, fat or thin, according to your preference.

There are a number of recipes for binders; it is perfectly possible, for example, to make a rather brittle pastel using gum arabic alone as a binder. The gum should be mixed with distilled water in a proportion of 1:20. Cellulose-based wallpaper paste will also work as a binder. The best binder, however, is gum tragacanth, which has been in use since the Egyptians used it in their wall paintings. It is readily available in art supply shops.

Pastels stored in uncooked rice to prevent damage.

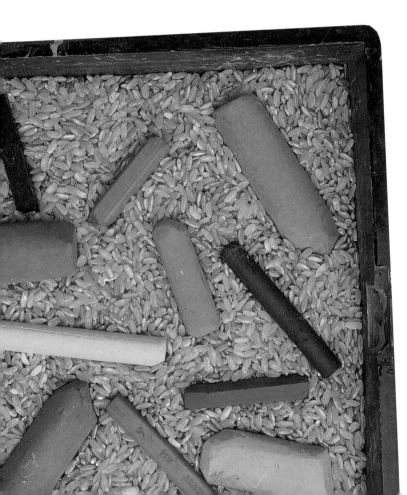

❶ *In a glass or ceramic mixing bowl, add one measure of gum tragacanth to five parts of distilled water. Add a few drops of beta naphthol with an eye-dropper, as a preservative. Because some pigments are likely to absorb more or less of the binding medium, this measurement can only be an approximation, so your first attempt at making pastels will be subject to trial and error.*

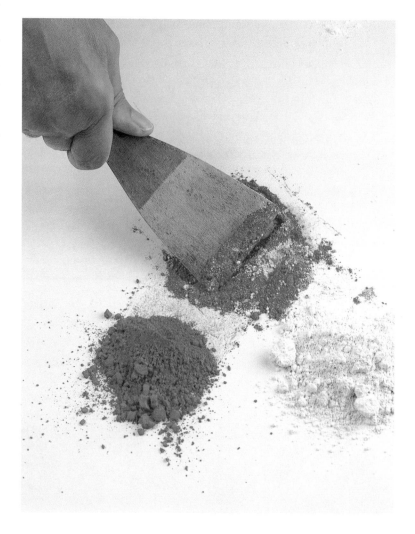

❷ *Pour some of the pure pigment onto a glass or marble mixing slab and add an equal quantity of white chalk. Mix the dry powders together thoroughly with a spatula and divide the mixture in half. Use one half to make the pastel and keep the remainder to reduce to paler tints of the same color.*

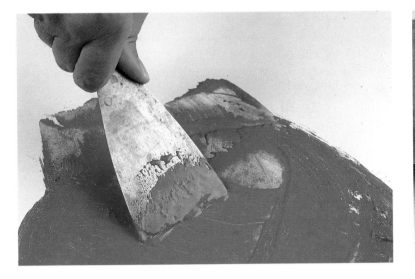

3 *Now add the binder, a few drops at a time, and blend to a stiff paste using a wedge-shaped palette knife. (For finer results, use a glass or stone muller for the grinding process.) The consistency should be firm, but not sticky. Scrape the mixture onto a sheet of blotting paper to drain off excess water.*

4 *Take a lump of the mixture and roll gently onto the slab using the length of the index finger. Be careful not to make the stick too thin. Place each molded stick onto a drying tray lined with a paper towel, and leave to dry for at least 48 hours.*

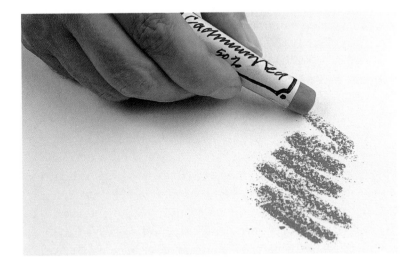

5 *I rather like the irregular shape of hand-finished pastels, but if you prefer a more uniform shape and size, you might consider making a simple mold. Write your own labels for the finished pastels, indicating the color and strength of the tint.*

LOOKING AFTER PASTELS

Pastels thrown together in a box tend to become dirty, as pigment dust transfers from one stick to another. Consequently, it becomes difficult to recognize the original color without first removing an outer layer of dust. Most of the pastellists I know are also inveterate collectors of old cigar boxes, which are ideal for storing pastel fragments. Good-quality soft pastels are expensive, but with a little forethought and care, they can last a long time. Warm and cool hues might be stored in separate boxes, and special tints and colors in another box. Loose pieces of pastel can be stored and separated from each other, either by putting a layer of uncooked rice in the box, or by using corrugated paper to create separate compartments. Pastels must be stored in dry conditions; moisture will promote the formation of mold.

Surfaces and Supports

Pastels demand a paper that has a raised surface texture, or "tooth." Whereas watercolors, gouache, and acrylics are absorbed into the paper itself, pastel stays on the surface. The action of drawing forces the pigment to be compacted into the minute hollows and ridges on the textured paper, an effect that is seen clearly under a magnifying glass.

Degas sometimes used tracing paper as support – mainly because he was able to place one sheet over another, continually correcting the drawing. These sheets were later glued to Bristol board. When using other papers, he would first soak them in turpentine so that the pastel pigment, when applied, would adhere more readily to the surface.

Apart from the texture of the paper surface, you also need to give some consideration to the color and tone. Would your subject, for instance, benefit from a warm or cool base color, or a pale or dark tone? Again, Degas often treated the base color of the paper as an integral part of the subject he was drawing. As I write, I am looking at a reproduction of a pastel of Ellen Andrée drawn by Degas. On the base color of green-gray, he has drawn the main outline of the figure in charcoal, which is overlaid with just three pastel colors – olive green, white/pink, and a rich plum. The total effect is of a color harmony.

TONED PAPERS

Ingres, Canson, and Fabriano papers are all suitable for pastels. Ingres paper is sometimes produced as a "laid" paper, which means that the surface texture of close parallel lines is produced by the wire mesh of the mold. The range of color and tone of these papers is extensive, but your choice will be determined to some extent by the subject. Light-toned papers, for example, are best suited to those subjects that demand a progression from mid- to dark tones. Middle-toned papers are most popular with beginners because they tend to enhance the paler tints of pastel color. The rich color and texture of a paper, however, cannot detract from any weakness in the drawing itself. Dark-toned papers are difficult to use and are reserved mainly for certain subjects such as interiors, where there might need to be greater contrast between light and dark tones. As a general rule, I would say that the color,

A selection of Ingres papers

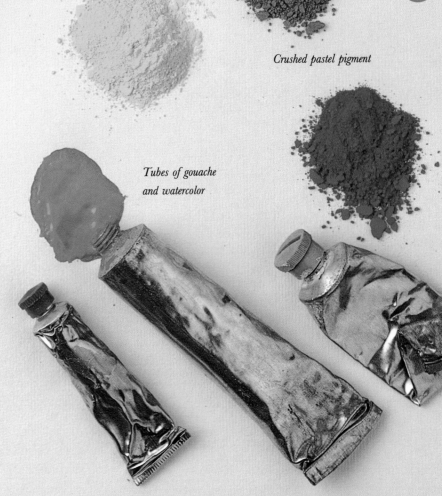

Charcoal

tone, and texture of the paper should not impose too much on the drawing itself.

There are some colored papers that have been given a surface very similar to that of fine sandpaper. These are produced in a range of pale and dark tones. I find that I am very sensitive to the tactile quality of paper, however, and although such papers are excellent technically, I dislike working with the kind of surface that produces a very mechanical-looking drawn line. Large sheets of fine sandpaper can, of course, be given a base color with gouache or acrylics.

TONING PAPER

Watercolor papers made from 100% cotton are sufficiently absorbent to allow an even tone to be laid on the surface. You can do this in a number of ways: for example, crushed pastel pigment can be taken up on a damp cloth and rubbed into the surface of the paper. Watercolor and gouache can also be diluted to produce a light or dark stain that can be brushed onto the paper. You may also like to experiment with other substances such as shellac or cold tea!

WHITE PAPER

If you prefer to work directly on watercolor paper, you will need to bear in mind the fact that pastel colors will appear to be slightly darker. If I am working with pastel on watercolor paper, I tend to combine it with charcoal, as I find that this helps me to get the tonal balance right.

Crushed pastel pigment

Tubes of gouache and watercolor

Cloth for rubbing pigment into the surface

CARDBOARD, MILLBOARD, AND CARPET UNDERLAY

Henri de Toulouse-Lautrec (1864–1901) and Edouard Vuillard (1868–1940) both used beige cardboard for pastels, gouache, and even oils. The paper used for underlaying carpets, which is thick and often has an interesting color and texture, is also very suitable for pastels. It often happens that when you are working on materials that cost very little, you feel less inhibited about making mistakes and, as a consequence, the drawing is often livelier and less constrained.

Different Papers

Barcham Green
"Crisbrook" Handmade
paper (unsized),
300gsm/140lb. Soft-
sized or unsized hand-
made rag paper is
particularly receptive to
chalk pastels.

White Canson
Mi-Teintes
190gsm/90lb. This is
an acid-free paper with
a soft, textured surface.
It is produced in a range
of tints and can be used
for pastels, crayons, and
watercolors.

Gray Ingres pastel paper.
fibrous paper is charac-
terized by the "laid" or
linear texture that breaks
up the stroke of
a chalk pastel in an
interesting way.

*Bockingford watercolor
paper, cold-pressed,
190gsm/90lb. This is
a robust, cold-pressed
watercolor paper that is
acid-free and can take a
lot of punishment.*

*Flock ...
sand-colored,
300gsm/140lb. The
soft "tooth" of this paper
retains the crispness of
the stroke – but
corrections are more
difficult.*

*Canford paper
190gsm/90lb. This
strong cover paper has a
smooth surface and is
manufactured in a range
of 51 matt colors.*

Additional Equipment

DRAWING BOARDS

If you intend to work both in the studio and out of doors, then you will probably need two boards: a heavy, wooden commercial board and a lightweight board (plywood, hardboard, or masonite) for sketching. Try to ensure that both boards are about 14 inches wider on all sides than the paper. It is advisable to use some sheets of old newsprint as padding between the paper and the board to produce a more tensile surface to work on, and to prevent pastels from breaking on an otherwise hard surface.

TABLES AND EASELS

Most pastellists prefer the sturdy support of a wooden table to an easel. There are exceptions, of course – an easel is far more useful when doing life studies or portraits. If you prefer an easel, make sure that all the joints are tight, as a sudden knock or too much vibration when drawing can very easily displace the fine pigment at a critical stage.

PASTEL ERASERS

Kneadable erasers are particularly useful when working with pastels since, as the name suggests, they can be kneaded into any shape or point to enable the artists to lift out the surface pigment of any part of the drawing to be corrected. Never rub or burnish the surface of a pastel drawing – this will simply produce a greasy smudge, and destroy the unique character of the chalk stroke.

Before using an eraser, brush away any loose particles of pigment with a hog's hair brush of the type used for oil painting. The same brush can also be used to make slight tonal adjustments before the drawing is finally fixed. Unwanted areas of pigment can also be gently scraped away with a flat blade. Make sure that the blade is absolutely flat against the surface of the paper.

Soft brush for blending

Kneadable eraser

Scalpel

Emery boards

Torchons

TORCHONS (PAPER STUMPS)

These can be used both for erasing the top layer of pigment, and for blending pigments together. The paper stumps are made in different sizes, but you can just as easily make your own from sheets of tightly rolled blotting paper.

BLENDING BRUSHES

Several large, soft, mop-haired blending brushes are useful, especially when working on a larger scale. Finer sable brushes can be used for small areas of the drawing, where you need to soften the effect without removing the pigment.

SHARPENING PASTELS

Use ordinary emery boards, or an emery board containing parallel sheets of fine and coarse emery paper as a base to sharpen pastels, by rubbing the stick across the surface. Alternatively, shave the edge to a point with a scalpel or craft knife.

Fixing Techniques

Artists who work frequently in pastel tend to regard fixatives as a necessary evil. This is due in part to the fact that fixative does tend to spoil slightly the dry, fresh color that distinguishes pastel from other media. There is a tendency for color to darken as the pigment absorbs the viscous spray. The problem can be overcome to some extent by "staggering" the process of spraying. A light spraying of fixative at each stage of the drawing will ensure that the pigment is stabilized without seriously affecting the brilliance of the color. This way, if there is any change in color after the fixative has dried, it can be corrected before the next stage.

Excessive spraying is common, and this, unfortunately, does the most damage to a pastel drawing, since the pigment is flattened or spread, by the force of the spray, into a paste-like consistency. It is better to under-spray than to saturate the paper. If you are using a fairly absorbent paper, it will help if you also spray the drawing from the back.

For convenience, fixative is available in aerosol spray cans. Alternatively, the fixative can be atomized through a folding spray diffuser (available from art supply shops). This offers a greater degree of control, since the flow is directed by blowing directly into the mouthpiece of the diffuser.

Cats are wise creatures – whenever I attempt to spray fixative on a drawing, my black cat departs with alacrity from the room! The fact is that the fumes are unpleasant and can be harmful to anyone with respiratory problems. Spraying should be carried out where there is plenty of ventilation.

SPRAYING PROCEDURE

Fix the drawing to a board or an easel, or lay it flat. First, make sure that the drawing is reasonably stable and that there are no loose particles of pigment. Keep the spray at least 12 inches from the surface, and use a sweeping action to direct the spray back and forth across the drawing in a continuous movement, to prevent the spray from becoming concentrated in any one area. Always test the spray on a sheet of scrap paper first, to make sure that the nozzle is not clogged.

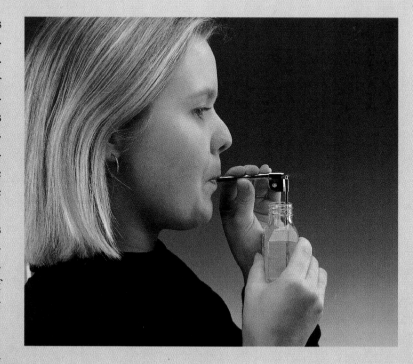

Using a mouth diffuser is an alternative to an aerosol spray.

Mouth diffuser

Home-made fixative

The aerosol is held firmly and used with a sweeping action at a distance of approximately 12 inches.

MAKING YOUR OWN FIXATIVE

There are numerous recipes for making fixative – the most suitable for pastel is based on casein, which is a glue derived from milk. Hilaire Hiler, author of the standard work *Notes on The Technique of Painting*, recommends the following recipe: Mix $^3/_4$ oz. of casein with an alkaline solution of $^1/_6$ oz. borax and enough distilled water to make a paste. After a few hours this becomes a syrupy mixture that should be thinned with $1^3/_4$ pt. of water. Add 1 pt. of pure grain alcohol, and, after the solution has clarified, it can be stored in an airtight bottle ready for use. (Ammonia may be substituted for borax.) Apply home-made fixative with a spray diffuser.

A basic, non-toxic fixative that is fairly reliable is non-fat milk; caseinogen is the soluble form of casein as it occurs in milk.

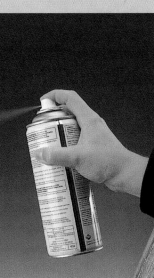

If you decide against fixing your pastels, then you should seal them behind glass in a frame. Make sure that you clean the glass of the frame with a damp cloth to avoid static electricity build-up, which would attract pigment particles to the underside of the glass.

Basic Strokes

Before I start work I sometimes like to stroll down to the seashore to see what has been washed up by the morning tide. Quite often, I come across a web of different-colored fishing nets caught up on the rock. In a way, this reminded me how, in pastel drawing, one builds up color with a web of cumulative drawn strokes, rather than by applying it in solid areas. Look, for example, at a Degas study of a nude bathing, and you will see how he seemingly carves out the form with vigorous intersecting strokes of pastel. Before you can draw with conviction, you will need to gain confidence in handling pastels, so that the marks you make have the recognizable quality of being your own. If you happened to have bought a new box of pastels, take one stick from the box and break it in half. Then, pick up a broken fragment and begin to make arcs, spirals, thin lines, and thick lines, with the kind of flowing gesture that comes from a supple writer. This kind of exploratory mark-making will enable you to gain the kind of control needed for more applied studies.

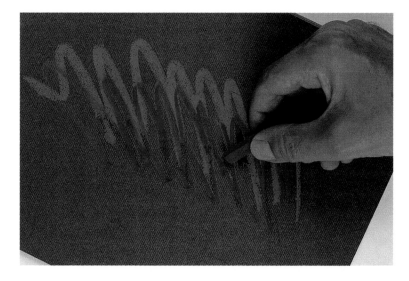

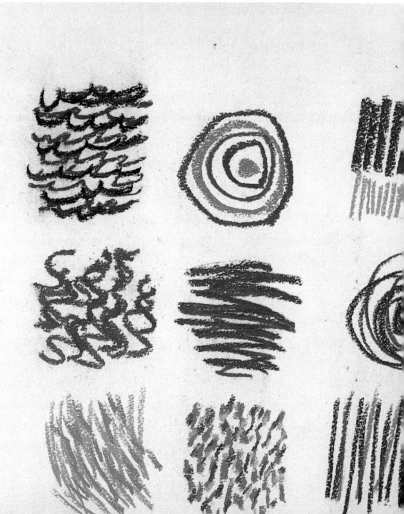

ABOVE *Practicing a basic, direct stroke with chalk pastels on a dark-toned Ingres paper.*

Notice how the grain of the paper influences the quality of the line.

TOP RIGHT *More experimenting, this time with three tones of one color on a dark paper.*

The type of paper used will, in part, determine the granular quality of the stroke. On a smooth paper, for instance, the pastel stroke will be more dense. On a rough paper, the stroke will be broken into a halftone by the "tooth." A laid paper will break the color with a series of fine, white, parallel lines.

Try drawing on different papers with hard and soft pastels. Begin with a single color, then try to build up webs of color in two or three layers of broad cross-hatchings. When using the cross-hatching technique, vary the space between lines. The closer the lines are together, the darker the tone will be. Try also interweaving complementary or discordant colors, or colors of the same hue, on light- and dark-toned papers. You will begin to see how colors blend optically as each hue, while retaining its own identity, also appears to blend with other colors in close juxta-

position. Color produced in this way is more kinetic than flat areas of color – which is why Degas's figure studies always seem to be in movement.

Hard pastels will generally produce better results when using this technique, especially when used on an HP drawing paper.

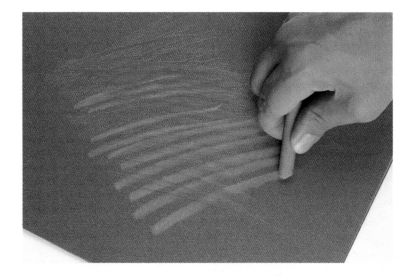

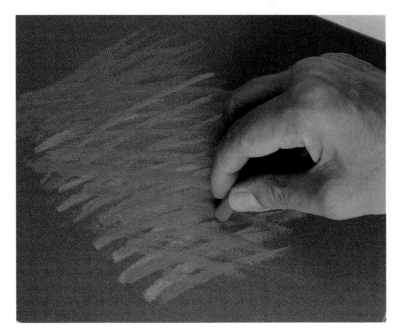

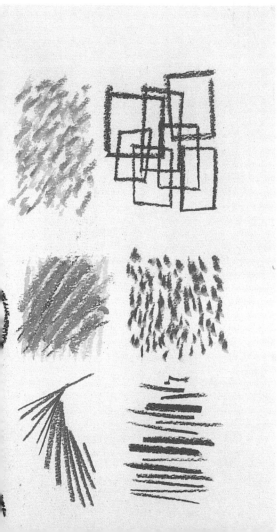

TOP RIGHT *A lighter tone of orange is hatched over the red, producing an optical blending of the two colors.*

RIGHT *A cobalt blue is hatched over the red and orange, creating the effect of movement.*

LEFT *Drawing random calligraphic squiggles is a good way to loosen up, so that your drawing action is less stilted.*

Building Up Solid Color

26

Most pastel drawings combine the kind of linear strokes we have already practiced, with solid or semi-opaque areas of pure and blended color. To produce a large area of color, it is best to use the length of the pastel laid flat on the surface of the paper. To create a continuous tone, the pastel is literally dragged over the surface, depositing a layer of color that is broken only by the texture of the paper. Further layers can be added by applying more pressure until the right tone has been established in relation to the rest of the drawing. Again, experiment with hard and soft pastels and different papers in order to discover the combination that suits your own intentions.

Without proper control, pastels can be twisted and turned on paper to produce a rather mechanical pattern; resist, if you can, the temptation to incorporate any slick marks into your drawing. Always try to make the medium work in the service of an idea.

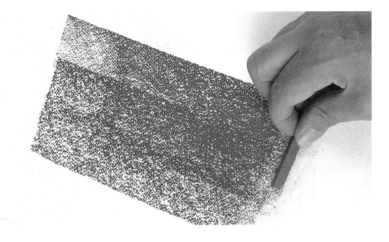

2 *A layer of solid red applied over the ultramarine intensifies the tone, as the two colors are blended together.*

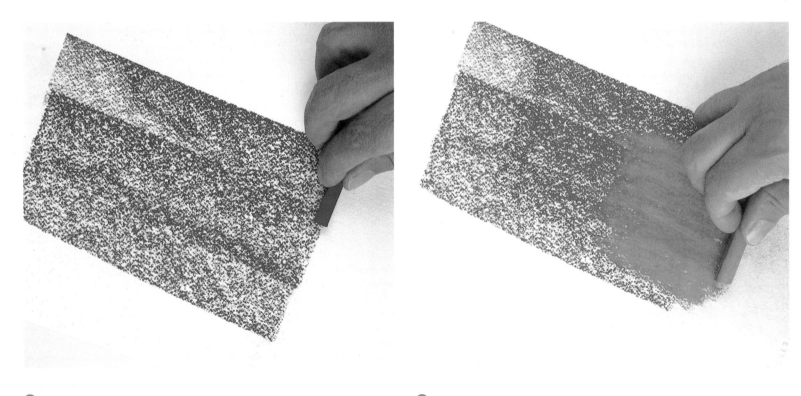

1 *Using the length of a stick of ultramarine chalk pastel to produce a continuous tone that is broken only by the grain of the paper.*

3 *A more intense blending of color is achieved by applying more pressure – the first two colors are almost cancelled out by a layer of Burnt Sienna.*

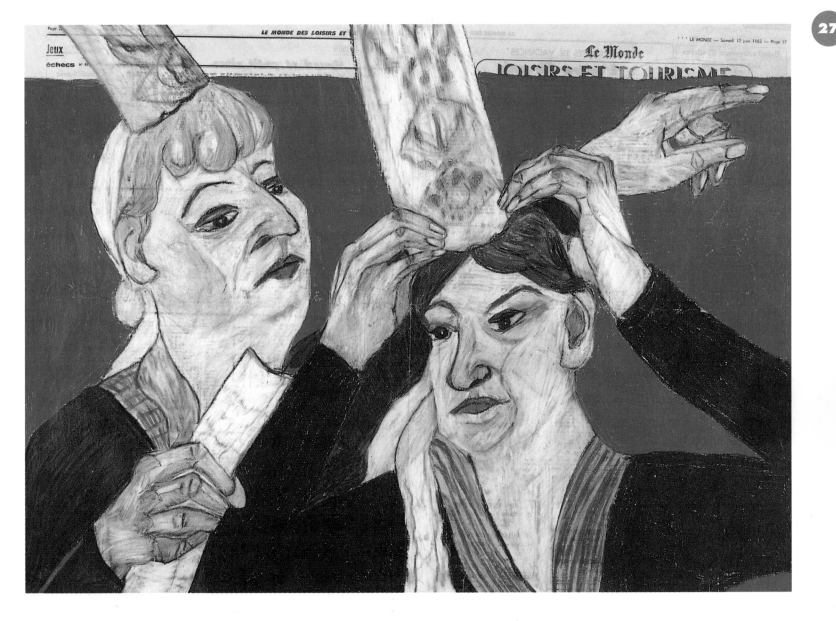

ABOVE *Illustration for a story by
Cecilia Hunkeler. The two old ladies
in traditional Breton costume are
drawn in solid layers of oil pastel,
working directly onto a double-page
spread of a French newspaper.*

Blending, Merging, and Feathering

28

One of the most attractive features of the medium of pastel drawing is that colors can be blended and fused together easily to produce the most beautiful gradations. Pastel colors, once put down, retain their luminosity and do not sink like other media. In certain conditions, the light is refracted by the surface of the pigment so that the drawing appears to stand in relief. Adjacent colors can be blended together with a fingertip, or with torchons, brushes, soft cloth, or tissue. Additionally, you can moisten the pigment by steaming it (as Degas did) before blending.

Of course, the blending of colors should only be done as an integral part of the overall drawing. In a landscape drawing, for example, you might want to suggest recession and aerial perspective by blending colors in the middle-distance and sky. When working on a still life, you might need to blend the color to suggest the form of curved or rounded objects. There are few occasions when you would use blended color alone – a seascape,

LEFT *A drawing of a life model using a feathering technique to suggest the fleeting quality of the light.*

LEFT *Using a soft brush to blend color in a part of the drawing where the pigment has become too heavy.*

RIGHT *Blending color by gently burnishing with a finger – this is the most direct way of fusing colors together.*

LEFT *A torchon can be used for blending local areas of color on a large drawing, especially in portraiture.*

perhaps, or a sky study – but, generally, blended color should be harnessed in some way by broken linear strokes.

MERGING

The effect of three-dimensional modeling is achieved by blending colors from a light tone to a mid-tone and then towards a dark tone in relation to the source of light. The eye responds to a variety of soft and hard forms, and in the best pastel drawings there is a balance between softly blended color, hard and soft edges, and a descriptive line that pulls everything together. The degree to which the linear element is either overstated or understated is determined by the nature of the subject. If, for instance, you wanted to say something about the intensity of light in a landscape seen at midday, you might ruin the whole effect if you allow for too much vigorous linear description.

Blending is a form of mixing color on the surface, and while this might produce interesting results with two or three colors, the technique becomes unworkable if too many colors are used; the colors become dirty and the paper will no longer retain the pigment.

For large areas of color – the sea, sky, or a field, foreground or background – it is best to use a finger or a soft rag to gently merge one color into another. For figure studies, where the drawing is prominent, I would tend to use a soft brush, so that, as the colors merge, part of the underlying contours is revealed. A torchon is used for blending color in small areas – when modeling the features of a portrait, for instance, or the intricate shapes of a flower study.

FEATHERING

Feathering color simply means drawing strokes rapidly, applying very little pressure. It is a technique that can be used to relieve the monotony of a flat, underlying tone, or to bring an overall unity to a drawing when the various disparate elements don't seem to jell together. Essentially, it is a means of modifying tones that are too light or dark. An area of a drawing that is too cool in tone, for example, might be feathered with a tint of red to correct the balance.

Drawing with Pastel Pencils

Pastels in pencil form are a convenient means of extending the range of the medium. Strips of compressed pigment $^1/_5$ inch wide are inserted into standard $^1/_4$-inch diameter barrels. They are produced in an extensive range of colors and can be sharpened like ordinary soft pencils.

The character of the stroke produced by a pastel pencil, however, is more acute than that of conventional sticks of hard and soft pastels. Nevertheless, you might find the pencil form of pastel easier to control and, as a result, your drawing might become freer and more lucid.

Ideally, pastel pencils are best used in conjunction with hard and soft pastels. I would tend to use them when drawing rapidly from

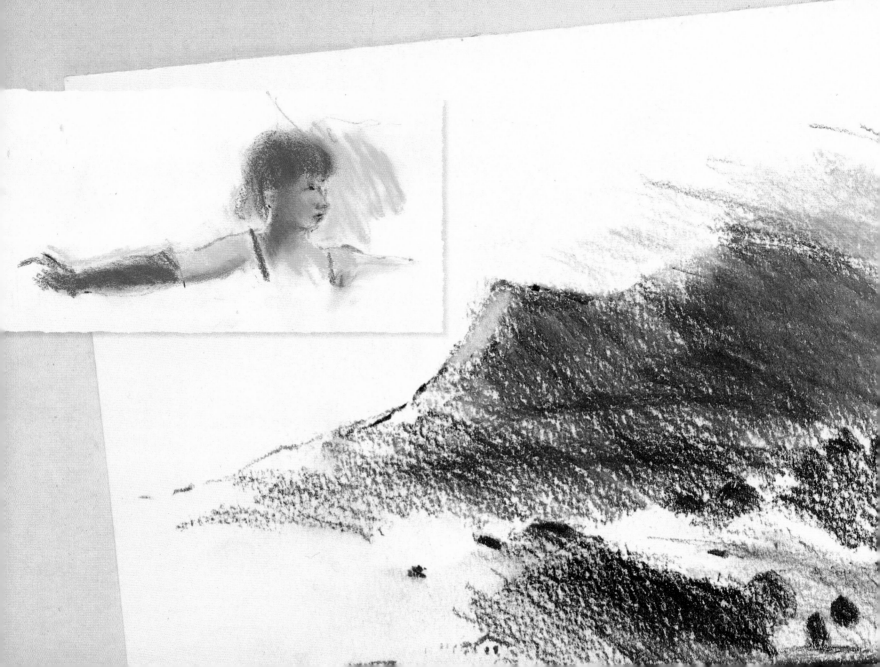

observation – for figure drawing, portraits, and sketchbook nota-
tions. They are particularly useful when trying to register archi-
tectural detail, or any complexity of form and structure.

Pastel pencils are useful
for making rapid sketches
on location – circus girl
(INSET) *and Mount Rigi*
on Lake Lucerne,
Switzerland (LEFT).

Oil Pastels

32

Oil pastels are really a species of oil paint. Because the pigment is bound in a greasy, oil-based substance, they are more malleable than chalk pastels, but the mark they produce is entirely different in character. They are generally more robust and less likely to break than chalk pastels, though in warm temperatures they can become too soft and sticky to handle. The color clings to the support in layers and is richer and deeper in tone. When burnished with a soft cloth, the color develops a sheen. The drawn stroke is less granular than that of chalk pastel, but the blending of color can be more luminous.

BLENDING OIL PASTELS

To blend one color with another, push the pigment with a fingertip into an adjacent color, so that they merge unevenly to produce a third color. Variations in pressure and temperature can result in a delightful "scumbled" effect. It is also possible to blend colors with a brush or soft cloth using a little white spirit. Try using this technique to produce wash-like effects in local parts of your drawing, such as the sky, or the general recession of color in a landscape or seascape. White spirit should be used with care, however, since it can weaken and dilute the drawn strokes in such a way that the work becomes too flat.

IMPASTO

If you are using oil pastels in an expressionistic way, building up an *impasto*, make sure that you have an adequate support. A fine, sand-based paper will anchor a number of layers of pigment to the surface. Alternatively, use cardboard or hardboard that has been primed with two coats of acrylic gesso.

LEFT *An exercise in overlaying color by applying varying pressure – using solid tints and hatched strokes.*

RIGHT *Sgraffito exercise – a scraping tool is drawn through the upper layer of ultramarine to reveal the base tint of pink.*

ABOVE *Exercise in merging and blending oil pastels.*

SGRAFFITO

Sgraffito is a scratching technique. It involves laying a flat color onto a paper support using a light or dark tone, then covering the first color with a second color that is darker or lighter in tone. Then the drawing is scraped or scratched out using a blunt tool, such as an old pen nib, so that the base color is revealed.

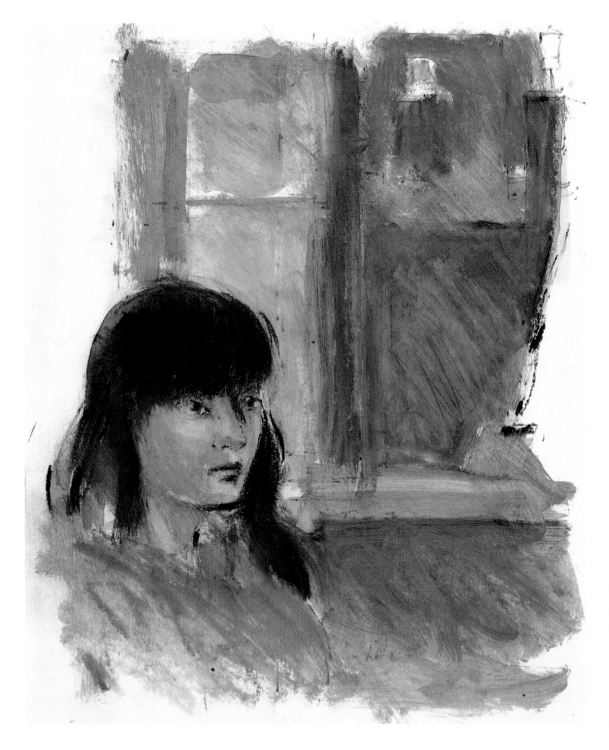

LEFT *A portrait using oil pastels that have been diluted in some areas with a brush and white spirit to produce a soft, semi-transparent tint, rather than an overall opaque tone.*

Different Colored Grounds

34

The French color theorist Michel-Eugène Chevreul (1786–1889), suggested that the close proximity of gray causes color to gain in brilliance. Because pastels are opaque and retain their brilliance, the use of a mid-toned pastel paper tends to induce an overall harmony and to enrich darker tones. By working directly onto a mid-gray paper, therefore, you will be better able to evaluate the tonal unity of the drawing.

If you are drawing in pastel onto a white or pale-tinted paper, the color initially looks brilliant. When all the colors are blocked in, however, you are forced to assess colors in relation to one another, rather than in relation to the white ground. This can make tonal evaluation difficult, and when pastel drawings fail it often has more to do with the tone than the color. The constant working and reworking of pastel on white paper can in itself create a tone, as the pigment is pushed around on the surface. For this reason, some artists like to use charcoal in combination with pastels when working on a white ground, because the softer gradation of the charcoal pigment influences the tone of the pastels.

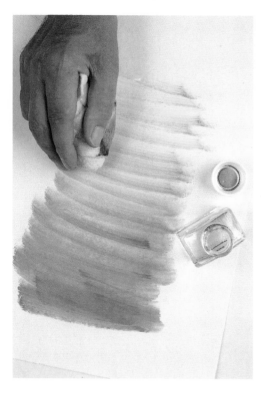

2 *The residue of pigment collecting at the bottom of your pastel box can be used to create a base tint by forcing the grains into the surface of an unsized paper with a soft rag.*

1 *An Indian Red oil paint diluted with a spike of lavender oil is rubbed into the surface of watercolor paper to produce a base tint. The tone can be even or varied according to the tonal strength of the drawing you intend to lay on top.*

3 *Gouache produces an ideal ground for pastel drawings, since it is a water soluble paint made from colored pigments and white filler, which produces a matt, chalky base that readily accepts chalk pastels.*

BELOW *This life study is enhanced by the warm tone of the paper.*

RIGHT *A color exercise using chalk pastels on soft, handmade plant papers. Notice how the dark-toned paper lifts the color values.*

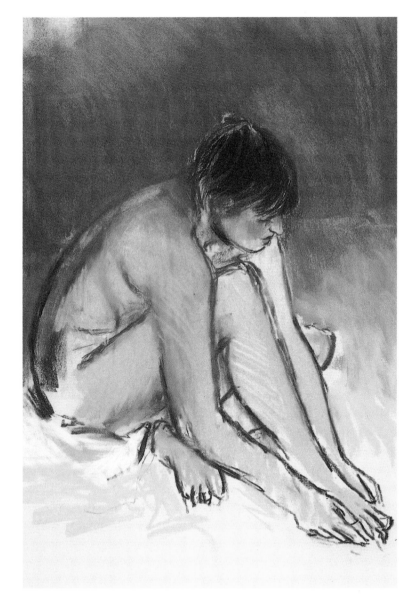

USING DARK-TONED PAPER

The experience of working on a dark-toned paper can be quite rewarding, insofar as it will enable you to gain a better understanding of tonal values by having to reverse the normal procedure of working from light to dark. The progression from the near black of the paper towards lighter tones and colors concentrates the mind on the essential elements of the composition. If, for example, I happened to be drawing the interior of a room on a dark-toned paper, I would begin by breaking everything down into simple, abstract elements. The basic shapes of doors, floor, wall spaces, windows, and so on can be registered in terms of simple blocks of interlocking color. Working in this way, the tonal progression can be worked out in simple steps. Try drawing on a dark-toned paper in circumstances in which you would not normally do so – you might even surprise yourself!

Color

THE THEORY OF COLOR

Color theory is really a convenient way of organizing and codifying color into divisions based on the spectrum. The difficulty lies in relating one's intimately subjective experience to the objective principles of color theory. Nevertheless, a basic knowledge of these principles can help to reinforce our own intuitive values. What is helpful is to learn how colors behave in relation to each other.

Sir Isaac Newton (1642–1727) demonstrated that although sunlight, or white light, is uncolored, it is made up of seven colored rays: red, orange, yellow, green, blue, indigo, and violet. We see color in objects that reflect and absorb these rays to a greater or lesser extent. The color wheel is really a basic illustration of the spectrum.

Yellow, red, and blue are the primary colors from which, theoretically, all other colors are made. Secondary colors (green, orange, purple) are produced by mixing any two of the primaries. Tertiary colors result from mixing a primary color and a secondary color together. In the manufacture of pastels, it is the addition of white that further extends the range of color by breaking down the strength of the primary, secondary, and tertiary colors into subtle gradations of tints.

Complementary colors refer simply to the "complement" of each color in its opposite on the color wheel – thus red is the complement of green. When complementary colors are mixed together, they cancel each other out.

If you look at the numerous colors and tints in a set of pastels, you will see that the colors based on red/yellow/orange and the earth colors are warm in relation to those based on blue/green/violet, which are cool. The brighter reds, yellow and orange are characteristic of such basic life forces as the sun and fire, whereas we find blues in the shadows of snow in a sunlit landscape. Warmer colors appear to advance and cooler colors recede when placed next to warmer hues. There are, of course, varying degrees of temperature within each color category. A vermilion is warmer, for instance, than a magenta red.

Degas was a superb intuitive colorist, and yet he claimed not to be preoccupied with color. He once said that he would probably have stuck to black and white if the world had not clamored for more and yet more of his vivid pastels.

Whenever I see a box containing dozens of chalk pastels, I always feel that the colors themselves suggest ideas. I can imagine grouping certain colors together to help me to give expression to unresolved or unformed images. And while there are so many tints and full colors to choose from, it is surprising just how much one can say with just a few, carefully selected colors.

We come to an understanding of color in different ways; some people approach the subject from the particular rules of color theory, while others rely entirely on intuition and intense observation. One can also learn a great deal from simply studying the work of artists who are known to be great colorists. There is, however, a danger in seeing the work entirely in the form of reproductions in art books – apart from the reduction in scale, the standard four-color printing process rarely gets the balance right in relation to the original.

COLOR HARMONY

There are essentially two ways of achieving color harmony. First, by color unity – using colors that are all to be found on one side of the color circle. A landscape scene, for example, might be rendered in a range of ochers, warm yellow, and burnt umber to produce a somber harmony. The second way of creating harmony is by contrast, using carefully balanced tones of warm and cool colors. Joseph Mallord William Turner (1775–1851), for instance, used often to compose his paintings in assiduously modulated colors of yellow/ocher towards blue/violet.

LIGHT AND LOCAL COLOR

The mixing and blending of color is usually done in an interpretive way, based on observation of how an object appears under certain conditions of light. The "local" color of an object refers to the actual color, rather than the color perceived when that same object is illuminated by strong light or immersed in shadow. Let us suppose, for example, that you were to paint two wooden cubes Cadmium Red. Then, that you placed one of the cubes in bright sunlight and the other in shadow. The "local" color of both cubes would be the same, but the perceived color value would be different.

It is easy to be certain about the "local" color of objects that are familiar – that we can touch or hold – but what is the "local" color of a mountain? We know that Paul Cézanne painted a series of studies of Mont Sainte-Victoire in Provence, France,

from a distance under different conditions of light. He was therefore concerned not with local color, but with producing a summation of his experience, which he represented by using an interaction of warm and cool color values.

If all of this sounds slightly confusing, there is no need for despair. You will find that your color sense increases with practice. Color is not something we see, but a way of seeing, and the way that we perceive color is conditioned by our past and present experience.

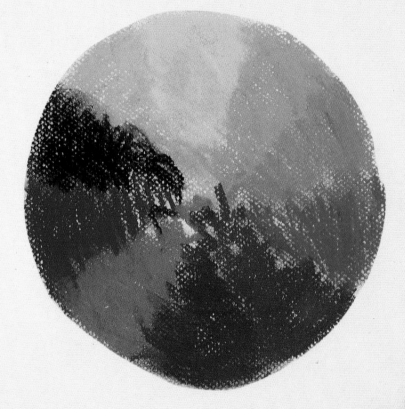

ABOVE *A loosely stated color circle drawn with chalk pastels: a great number of graded tints can be produced from each base color.*

Tone

38 olor should not be thought of as being a separate entity from tone; every color has a tone. For instance, Prussian Blue and Burnt Umber are opposites in terms of color, but both have approximately the same tone. Tones are produced by the quality and intensity of the light that is reflected from an object. Again, we need to be able to distinguish between the "local" tone and the way that a tone is modified by the quality of light that falls on any object. A house seen in sunlight from a distance will appear to us as a solid, three-dimensional object by virtue of the fact that the plane turned towards the source of light will be lighter in tone than the elevations that are turned away from the light. On a dull or a misty day, all such distinctions of tone would be leveled out or lost.

All pastel drawings need to have a tonal scheme; it is difficult to employ strong colors *and* strongly distinctive tones together. In the main, it is a question of balancing the strength of the color against the strength of the tone. Many artists use colors that are close in tone; Vuillard, for example, used very subtle variations of tone in his distemper paintings and pastels. Pastel tints are close in tone, and the fact that one can achieve such delicate variations in both color and tone is part of the charm of the medium.

The mechanical tones of the photographic print have in part conditioned the way artists tend to use tone, in terms of clearly defined stepped gradations. I believe that you need to look harder to uncover those barely perceptible changes of color and tone that cannot be registered on photographic film. In the best tonal studies, detail is sacrificed in order to place more emphasis on the atmospheric and spatial dimensions of the subject.

THREE-TONE TECHNIQUE

As an exercise in tonal control, select three pastels of the same hue in a pale, mid-, and dark tone. Then, choose an object from your kitchen – a bowl, jug or coffee pot, perhaps – and try rendering both the object and background using only the three tones. Begin with the palest tone; not just as a background color, but also as an underlying tone for the other colors. Use the mid-tone to express modeling and the darkest tone to produce the contrast.

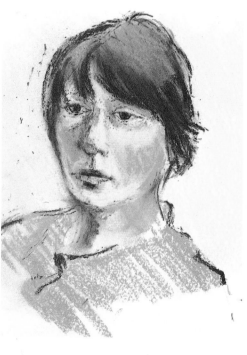

ABOVE *Gradations of color drawn on a tonal scale. This simple exercise can help your understanding of the variety of tones that can be produced with pastels.*

LEFT *A portrait drawing using three tones: pale Naples yellow, Olive Green (tint) and Raw Umber. Greater tonal unity is achieved by using just a few closely related colors.*

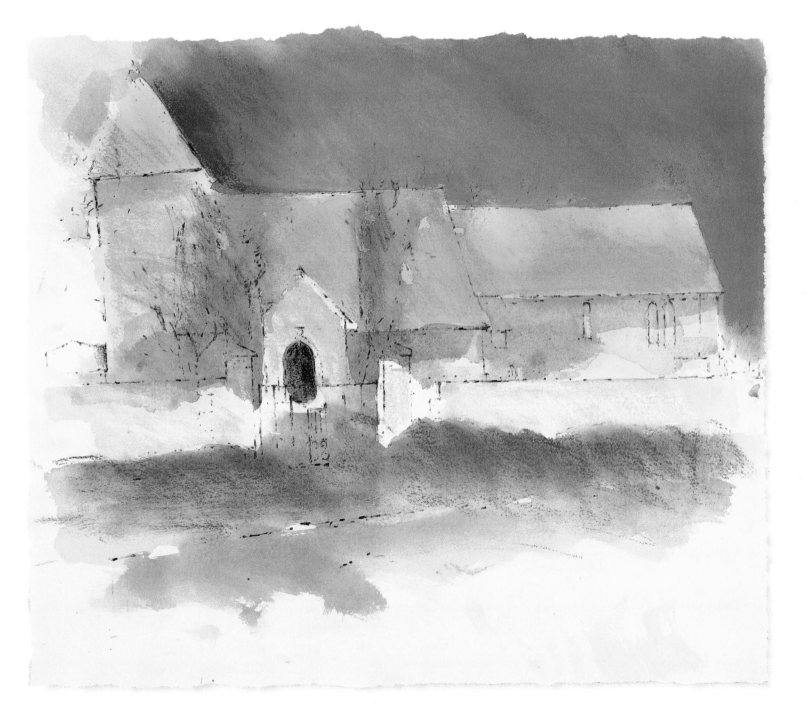

ABOVE *Church at Tarring Neville, East Sussex, England. This tonal study employs warm and cool hues of chalk pastels overworked onto a base of watercolor washes.*

Charcoal and Conté with Pastels

40

Pastels can lend themselves to be combined very successfully with a variety of other media. Charcoal and conté crayon are the most usual partners for pastels.

CHARCOAL AND PASTEL

Charcoal is the oldest and most natural of drawing media. It is capable of producing soft and precise lines that are easily corrected. Charcoal is made from either willow or vine, which is fired at high temperatures to carbonize the wood but allow it to retain its shape. It is manufactured in different sizes, from fine sticks to the thick blocks that are used by theatrical scene-painters. It is also produced in pencil form, with varying degrees of softness.

Compressed charcoal is made from lamp black pigment mixed and compressed with a binder. It is more dense and less sensitive than ordinary charcoal.

Degas was concerned with capturing the sudden movement of fleeting incidents – the jockey maneuvering for position at the start-ing gate, a dancer adjusting her shoes, the laundress ironing. All these subjects demand the kind of medium he could handle inveterately. With charcoal he found that he could rapidly build up a tonal range – from the slightest trace to the bold and vigorous lines that provided the underlying structure to many of his pastels.

CONTÉ AND PASTEL

Conté crayon can also be successfully combined with pastels. They are much firmer than charcoal, and produce a crisper line. Originally, conté crayons were produced in black, white, sanguine, bistre, and sepia, although the range has now been extended to include other colors. The basic set of five colors, however, is ideal for working within a limited tonal range. Try, for instance, producing a pastel drawing using a conté sanguine, white, and a single pastel tint on a mid-toned paper. It sometimes happens that this kind of self-imposed limitation can produce a result that is far more complete than if you had used a hundred pastels.

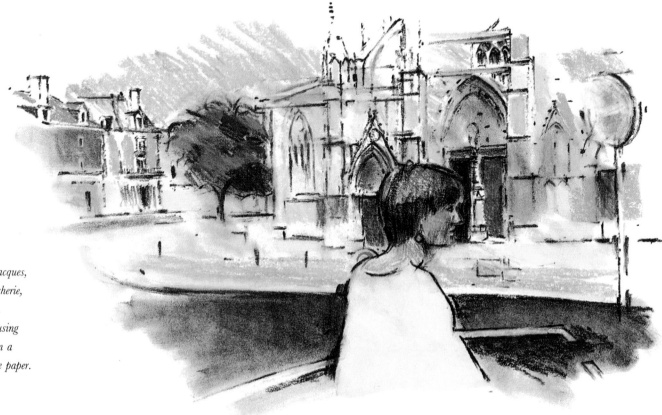

RIGHT *Ste. Jacques,*
Rue de la Boucherie,
Dieppe, France.
A rapid study using
pastel pencils on a
smooth cartridge paper.

ABOVE *Young woman sewing. The intense concentration of this pose is captured in a rapidly stated charcoal study overlaid with hatched chalk pastels.*

LEFT *Figure study using heavy tones of conté crayon to isolate and intensify tints of pastel.*

Gouache and Watercolor with Pastels

42

GOUACHE AND PASTELS

Gouache and pastels are really members of the same family. When Degas steamed his pastels, he produced a paste-like color that is difficult to distinguish from gouache. Like pastel, it is opaque, and the particular combination of flat tones of gouache and chalky irregular patches of pastel can be very satisfactory. Sometimes called "body" color, gouache is made from the same colored pigments as pastels, with varying proportions of white filler, and is bound in gum, which makes it water soluble. It can be used with a brush almost starved of water to produce a dry color, or heavily diluted, to render washes.

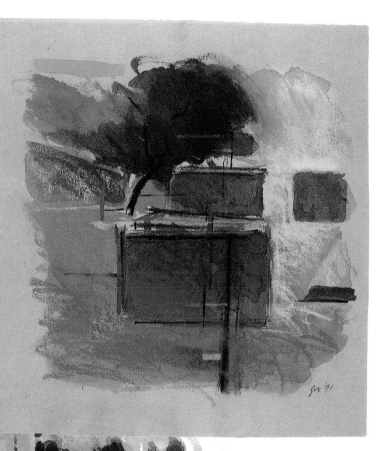

ABOVE *Ancient stones – Olympia, Greece. This drawing combines gouache and chalk pastels worked onto a toned paper.*

LEFT *Sainte Bénézet Bridge – Avignon, France. Pale washes of watercolor were applied as an underdrawing before reworking with chalk pastels.*

WATERCOLOR AND PASTELS

Watercolor is pure pigment mixed with a gum binder. The difference between gouache and watercolor is that the former is made opaque by the addition of white filler. Watercolor deposits a transparent film of pigment on white or toned paper; it can be combined with pastels, providing that you use a paper suited to

both techniques. It is important to get the balance right between transparent washes of color and the overlaid, opaque strokes of pastel. Generally, watercolor works best as a kind of undertone or ground for pastel drawings. Alternatively, try adding a little ground rice flour or cornstarch to the watercolor. This produces a gritty color that is more akin to pastel.

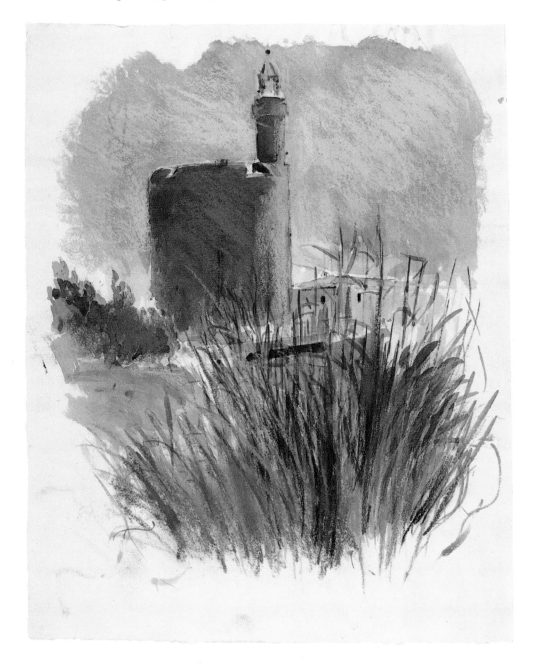

LEFT *Aigues Mortes, The Camargue, France. This drawing, made on site, began with a rough pencil drawing overlaid with broadly stated washes of watercolor. When dry, chalk pastels were worked over the surface to produce softer hues and richer tonal contrasts.*

ABOVE *Sketch made near the village of Le Tholonet, France – a ten-minute study that combines watercolor and chalk pastels.*

Monotypes, Essences, and Pastels

44

Degas was adventurous when extending the pastel medium to combine with others. He invented several new techniques.

MONOTYPES AND PASTELS

Degas often used a monotype base for his pastels, which gave the work an atmospheric quality redolent of lithography. A monotype is a drawing or painting made directly onto a sheet of glass with dilute oil paint. While the painting is still wet, a sheet of paper is laid on top and the back is gently burnished so that the film

of paint is transferred to the paper. It is then lifted from the glass to reveal the image in reverse at about half the strength (tonally) that it was originally painted. Providing that the paper is fixed with a hinge of masking-tape to register its position, more color can be applied to the existing drawing on the glass, and a second impression made. If you are worried about the fact that the image appears in reverse, you can overcome this by initially placing a keyline drawing (already reversed) under the glass to act as a guide before you start painting.

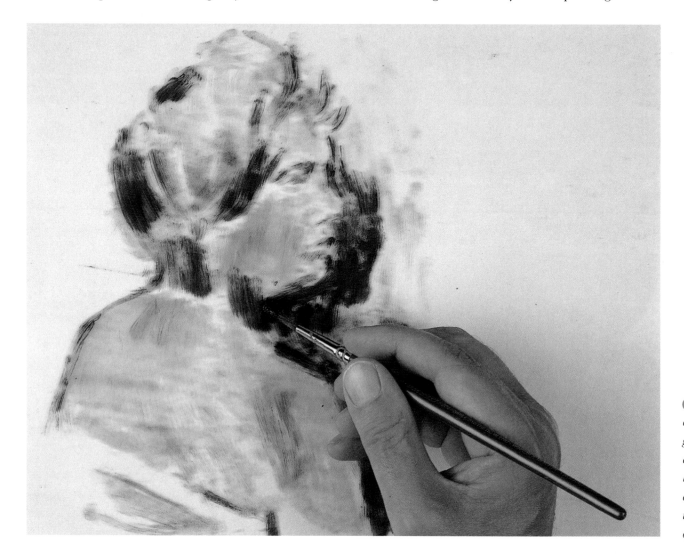

1 *The image is painted directly onto a sheet of glass with oil paint diluted with a spike of lavender oil. Mistakes can be easily corrected at this stage by wiping them off with a soft cloth.*

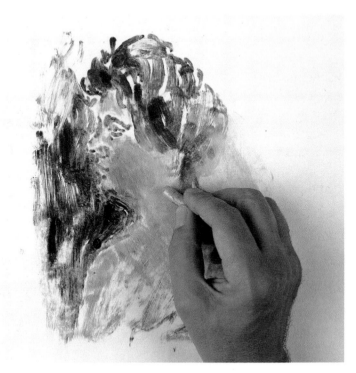

2 *A sheet of drawing paper is laid face down on the glass and gently burnished from the back with a spoon.*

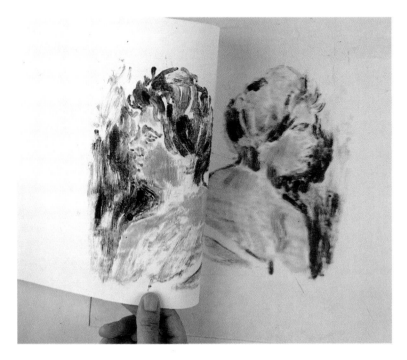

3 *The print is carefully lifted to examine the quality of impression – if it is too pale, it can be put back and burnished again, or if the paper is firmly hinged with tape, more color can be added.*

4 *When dry, the monotype print can be worked over with chalk or oil pastels.*

ESSENCE AND PASTELS

Degas used also to paint directly onto paper with essence (oil paint diluted with essential oils). Spike of lavender is good for this purpose, since it is slow-drying. This technique produces a pale, ghost-like image on which the pastel drawing can be built up. Again, it is a question of restraint in deciding just how to balance this kind of mixed-media technique to produce a satisfactory drawing.

Space, Depth, and Perspective

46

From the moment that I make my first mark on paper, I am beginning to establish a spatial dimension between that mark and the surface area of the paper itself. Then, as I begin to place patches of color side by side, the varying color and tone of each plane will suggest depth and recession. Some artists, for example, begin a pastel drawing by laying down large masses of broadly stated color in order to establish right away the illusion of three-dimensional space. But the actual placement of those masses is of critical importance to the success of the drawing. Detail is of little consequence at this stage – if the basic spatial plan is

unsatisfactory, then no amount of intricate topographical flourish can save it. We use color and tone to control space. Color advances and recedes and suggests in a symbolic way the sense of depth and recession in a drawing or painting.

Begin with a subject that can be broken down into simple shapes – a landscape perhaps, or an interior. Make a number of diminutive pencil sketches to establish the essential design of the subject in order to clarify, in your own mind, the way that planes are separated from one another in space.

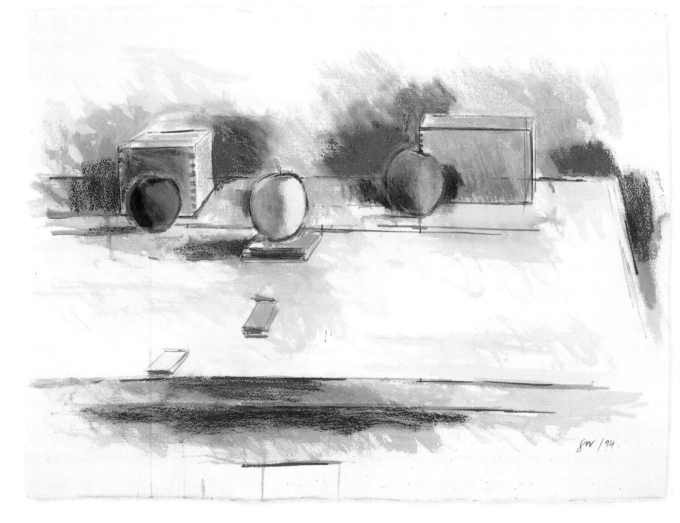

LEFT *Still life – Three apples are carefully placed on a table top in relation to each other and to the wooden boxes and blocks. This is a useful exercise, not only in terms of perspective, but also in visual judgement and composition.*

RIGHT *Landscape, Spain. Aerial perspective is suggested in a very subtle way in this drawing: the artist has worked on a mid-toned paper, which unifies tones, from the palest pink of the distant mountains to the rich umbers of the scrubland in the foreground.*

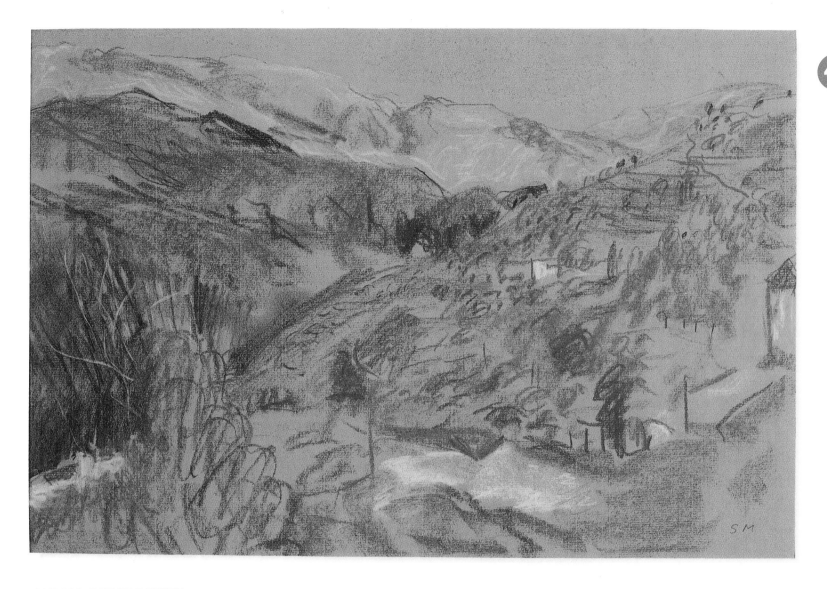

AERIAL PERSPECTIVE

We can also create a sense of space in landscape by considering the effects of aerial perspective. The pellucid veils of atmosphere (particularly in the northern hemisphere) reduce tones and make colors become cooler. For instance, you will have noticed how distant hills and mountains sometimes take on a tint of blue. The darkest objects in the foreground lead the eye towards the middle distance and on to the palest tones on the horizon.

Try to avoid thinking of aerial perspective as a formula or visual cliché – be selective and hint at the impalpability of changing light values, rather than record too much detail. In his *Leaves from a Notebook*, Thomas Aldrich says, "I like to have things suggested rather than told in full. When every detail is given, the mind rests satisfied, and the imagination loses the desire to use its own wings."

This, in my view, is what drawing in pastel is mainly about. It is a medium that lends itself to the recording of those incidents in everyday life that are transitory – a landscape briefly illuminated by the sun, or figures in movement or informally posed.

Composition

> "
> *Even in front of nature, one must compose.*
> "
>
> Edgar Degas

Degas was acutely aware of the way that pictorial space needed to be organized in a logical way, even though his pastel drawings appear to be informal and spontaneous. "I assure you," he said, "no art was ever less spontaneous than mine."

His original approach to composition was influenced by the unconventional – to western eyes – compositions of Japanese prints, and by the photographic "snapshot." This led him to view his subjects from unexpected viewpoints and angles.

We can define composition as the logical disposition of the elements in a drawing or painting. This is not to suggest that everything we draw or paint must be subjected to some kind of pre-ordained plan. We sometimes unconsciously put things down in a particular part of a drawing, simply because it seems right to do so. Again, we should pay attention to the master pastelist, Degas, who said that a picture is an original combination of lines and tones that make themselves felt.

The way that a picture is composed, therefore, might depend on exactly what our intentions are in relation to the subject. If, for example, I wanted to evoke the essential mood of a low-lying landscape in Holland, I would probably place the horizon line fairly low in my composition, with two-thirds or more of the pictorial space devoted to the sky.

RIGHT *Compositional analysis of the pastel drawing by Degas, known as* The Tub *(1886). The strong diagonal line on the right of the figure corresponds to the Golden Section.*

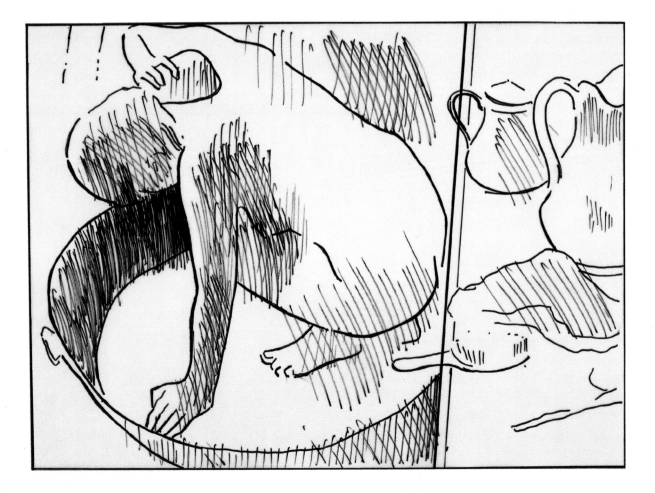

The whole process of composing a picture can begin long before you even start to draw. It is difficult to say why one place should command more interest than another, but I believe it has something to do with the particular relationship of parts; the way that in a landscape, for instance, all the elements – hills, trees, rivers, and synthetic artefacts – are disposed. Then you begin to try to visualize how you might bring these disparate elements together in a drawing or painting. One advantage that the artist has over the photographer is that he or she can leave out unwanted detail and even move a tree, a building, or any other element, to produce a more satisfactory composition.

We must begin by relating the composition to the dimensions of the paper we are working on. Scale is an important factor – things are never isolated, but are relative. Degas produced two pastels with the title "The Tub." In both drawings, the circular form of the metal tub is critically placed to act as a foil to the figure itself. The drawings are composed in such a way that every element counts – whether it's a hairbrush, jug, or the edge of a chair. Nothing is allowed to distract from the essential relationship of the figure and the tub.

THE GOLDEN SECTION

The division of space known as the Golden Section is the best-known device for dividing the picture plane aesthetically. It is based on the idea that the proportion of the smaller to the larger is the same as the larger to the whole. An easy way of finding the Golden Section of any given rectangle is to take a sheet of paper of the size you are working on, and fold it in half three times in succession. Do this for both the length and breadth of the paper. The folds will divide the paper into eight equal parts, from which a 3:5 ratio can be determined. Alternative ratios might be 2:3, 5:8 or 8:13. This device works best in compositions in which one needs to draw attention to a single vertical element – a standing figure, a tree, or even a telegraph pole.

Yet, if we accept what Degas said about combining lines and tones that make themselves felt, we must also consider contrast, light and tone, movement, and the relationship between all these things. This may sound like a tall order when all you want to do

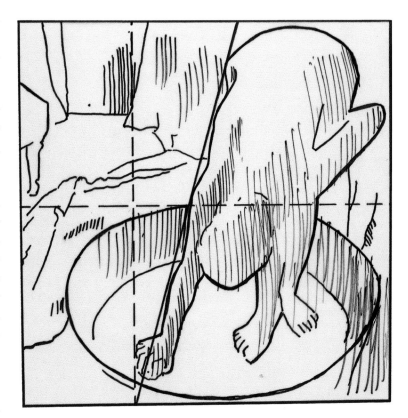

ABOVE *Compositional analysis of a second drawing by Degas, also known as* The Tub, *and produced in the same year.*

Notice the strongly diagonal accent of the pose and the way that the circular tub fits perfectly into the lower half of the composition.

is begin drawing the scene in front of you, but try to get into the habit of being more selective. If it helps, make a simple framing device by cutting a square or rectangle from a piece of black cardboard. Use it to frame the image to emphasize what you want. When you are seated in front of your subject, ask yourself which particular qualities about the subject interest you most. Then, try to compose your drawing in such a way that you draw attention to those qualities.

Translating what we See

> *…he who can interpret what has been seen is a greater prophet than he who has simply seen it.*
>
> St. Augustine (AD 354–430)

We see what we expect to see, and what we expect to see is all too often conditioned by the way that other artists have interpreted various subjects before us. Although, for instance, I have made frequent references to Degas in this book – because he is an artist I happen to admire – I would not wish to emulate his style in any way, nor would I be particularly interested in his choice of subject matter. We must try to discover the world in our own terms, and be able to translate what we have seen through our chosen medium, without being affected too much by what other artists have done. We need to find a way of communicating our discoveries in a very personal way. The so-called

"primitive" painter Alfred Wallis (1855–1942) who, in his old age, painted sailing ships and Cornish harbors onto scraps of wood and cardboard, worked essentially from memory (of his days at sea) and imagination to convey images that are far more telling than those produced by "trained" nautical painters who invested the same subject with densely packed incident and detail.

Nobody should have to tell you what to draw or paint; you need to be interested and excited by a subject for your own reasons. You might find it necessary to heighten certain color contrasts or exaggerate the scale of things in order to make a particular point about the subject you are drawing. The degree of detail or finish invested in any drawing is dependent on just how much information you need to express to enable others to follow what you are trying to say. It is not necessary, for example, to draw every leaf on an olive tree for others to identify what species of tree it is. The artist should be judged by what he or she actually does with his subjects, not by what the subjects are.

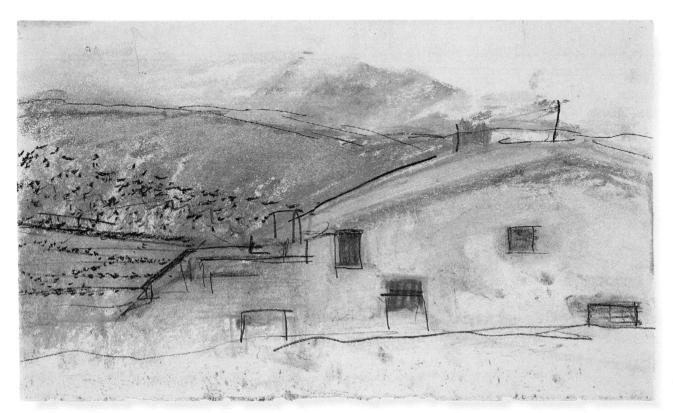

LEFT *Spanish landscape. This is a good example of the way that the quality of light can be translated convincingly with just a few chalk pastel colors.*

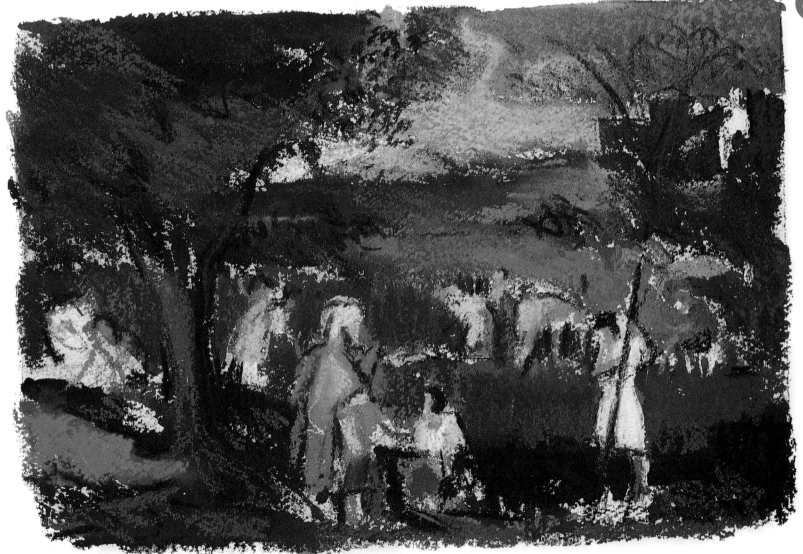

You may find that you are excited by a particular subject not because you are actually interested in its intrinsic value, but because it allows you to explore values that are independent of the subject. For example, it would be possible for someone to produce an interesting pastel drawing of, say, a frying pan, a saucepan, and a jug, without being interested in those objects *per se*, or attaching any meaning to them.

ABOVE *A rough pastel transcription from Poussin's painting "Summer." The purpose of this exercise is not to produce a copy, but to interpret the main forms and color relationships in a different medium from the original.*

Depicting Mood and Atmosphere

> 66
>
> *See this layered sandstone among the short mountain grass. Place your right hand on it, palm downward. See where the sun rises and where it stands at noon. Direct your middle finger midway between them. Spread your fingers, not widely. You now hold this place in your hand.*
>
> from *Black Mountain* by Raymond Williams
>
> 99

The work of certain writers, painters, poets, photographers, and even musicians is often inextricably linked with a particular place or region. By close association you learn to uncover the spirit of a place, and to be cognizant of different levels of feeling. Turner's paintings varied dramatically in mood and atmosphere; from storms at sea and over the Alps to the calm and brilliant scenes of the Venice lagoon and hazy views of English castles seen at sunrise.

What do we mean when we say that a drawing or painting is atmospheric? "Atmosphere" contains a duality of meaning; the particle-laden body whose transparency is dependent on variable atmospheric pressure, and the pervading mood of a place which in turn evokes certain feelings and emotions. Additionally, the mood and atmosphere of the work might also be dependent on the state of mind of the person producing it. Whereas I might depict a fishing harbor as a scene that reflects a kind of tranquil sadness, another artist might view the same scene in a more joyful and exuberant frame of mind.

We use color by association to suggest mood, sometimes contrasting bright complementary colors with more somber hues, or cooler colors to express quietude. One must be cautious, however, in confining color values to such convenient categories.

ATMOSPHERE AND LANDSCAPE

When drawing a landscape or an architectural subject, we sometimes need to be patient, waiting for that time of day when the conditions of light will enhance the mood and atmosphere of the subject. Mountainous regions, for instance, are best seen in mist or after rain, when distances are difficult to define and contours less sharp. It might be necessary to rise at first light or wait until dusk to heighten the drama of the subject. In attempting to evoke the atmosphere of a place, you need to be more attentive to the influence of light than to the representation of detail. Light waves are conditioned by the way that they react to various substances – water, mist, cloud, stone and so on. Even under direct sunlight, the actual intensity of the light varies considerably from one part of the landscape to another. At sunset or sunrise there is a scattering of light caused by the molecules of air and by the presence of dust and moisture in the atmosphere. And when the sun is overhead at noon, the light waves have a shorter distance to travel than at dusk or early morning.

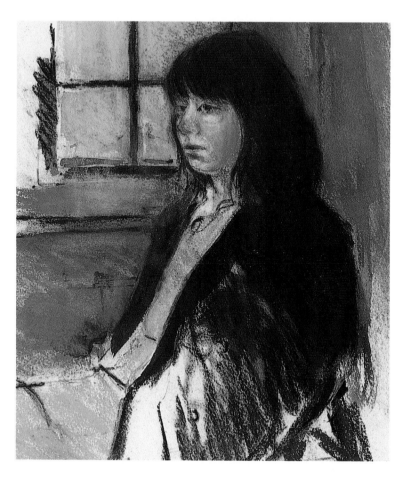

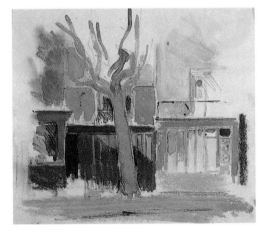

RIGHT *Stores in the Rue de la Ste Catherine, Dieppe, France. An intimate study in winter of this small square, which has changed little since it was painted by Walter Sickert in 1900.*

INTERIOR MOODS

When working on interior subjects, one can work with the available light source from doors and windows, or under artificial light, which can be controlled to some extent. Vuillard produced his most atmospheric pastels in the intimate surroundings of his own home. Start, then, with those subjects you know and love best, and remember, although this may sound like a truism, you are more likely to be aware of the mood and atmosphere of your own surroundings than you would be in unfamiliar territory.

LEFT *The mood of this drawing is largely determined by the low level of the available light source from the window.*

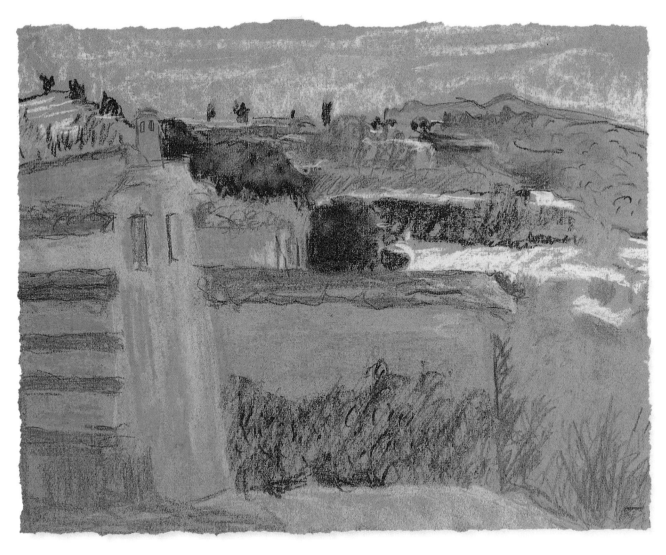

RIGHT *Spanish landscape. A study of the rooftops in a white village seen around dusk, a time when contrasts are softer and colors more muted.*

Sketchbook Notations

54

John Constable (1776–1837) always carried a pocket sketchbook with him on his forays into the countryside. He used a sketchbook for what he called his "hasty memorandums" – page after page was filled with diminutive studies in pencil of trees, skies, hedgerows, farm laborers, and the effects of light and shadow on the landscape.

We use a sketchbook as a kind of visual diary to make personal notations of things seen, which may not be meaningful to anyone else. Pastel is an ideal medium for working in sketchbooks; no brushes, water, or unwieldy equipment is required – only fixative, perhaps, or tissue between pages to prevent smudging. I prefer a spiral-bound sketchbook with assorted colors of Ingres paper. Sketchbooks made up from watercolor paper are also suitable. You can, of course, make up your own sketchbook using a variety of papers – I sometimes use a very thin Japanese paper, especially if I am combining charcoal with pastel. I have also seen some very beautiful pastel drawings in France that were produced on newspaper.

A sketchbook sets you free from the formal constraints of trying to produce a "finished" pastel drawing. You should use it to take risks and to push the medium to extremes. In other words, don't be precious about it – use your sketchbook as a useful working tool. It sometimes happens that an artist's best work is to be found in his or her sketchbooks. This has something to do with the fact that all the freshness and conviction of the initial study is lost when it becomes formalized on canvas or paper. The difficulty in using sketchbook studies as reference for work produced on a larger scale in the studio is to maintain the spontaneity of the original study.

LEFT *Tree forms. A sketchbook study in charcoal.*

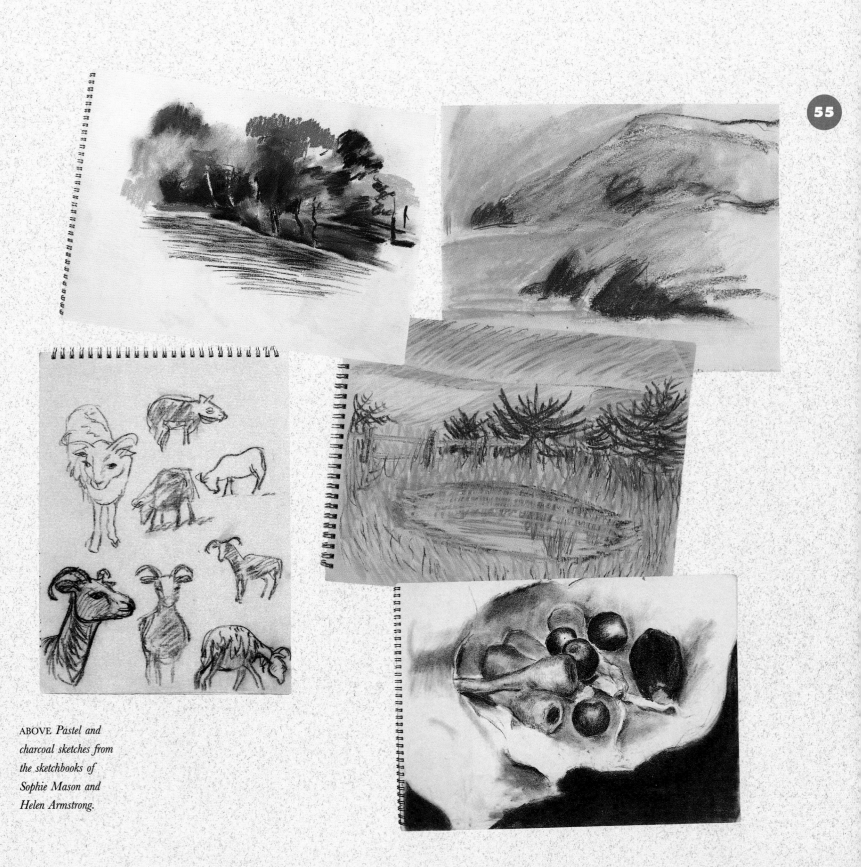

ABOVE *Pastel and charcoal sketches from the sketchbooks of Sophie Mason and Helen Armstrong.*

THE
PROJECTS

How the Projects Work

The first part of this book explores the essential characteristics of the pastel medium through a series of basic exercises. Specific techniques such as feathering, blending, and impasto are described and are evident in the drawings reproduced. We have also seen how pastels can be combined with other media. We need, however, to be mindful of the fact that, although we must necessarily gain experience and confidence in handling technique, we do so in order to fulfil our intention to communicate a particular point. We need to be able to translate what we see in terms of the medium we are using and to be aware of the problems of color, tone, composition, and perspective.

In the project section that follows, you will see how all these basic techniques are put into practice with varying degrees of success. Three artists have worked simultaneously on a series of ten projects using the same sources of reference. The projects range from basic tonal studies to more complex themes.

The brief introduction to each project summarizes the problems posed by the subject in relation to the medium. At the conclusion of the project there is a critique, which examines both positive and negative aspects of the completed work. Additionally, in the final stage of each drawing, we can see whether or not the problems outlined in the introduction have been addressed and worked through. The readers will, of course, draw their own conclusions from all of this and will, one hopes, feel sufficiently encouraged to want to produce drawings in pastel that reflect a personal response to similar themes, or even to subjects that are beyond the scope of this book. All projects use chalk pastels unless otherwise indicated. Color names given in the text may vary, depending on the proprietary brands the artists used.

HELEN ARMSTRONG trained as a painter and printmaker. She specialized in lithography, and the influence of that medium is evident in the way she handles chalk pastels. She is an experienced teacher and has worked in secondary education as well as in adult education. Her work has been exhibited widely in England, Rome, Barcelona, and Krakov.

She has been occupied with portraiture for some years, but has recently started to draw and paint landscapes.

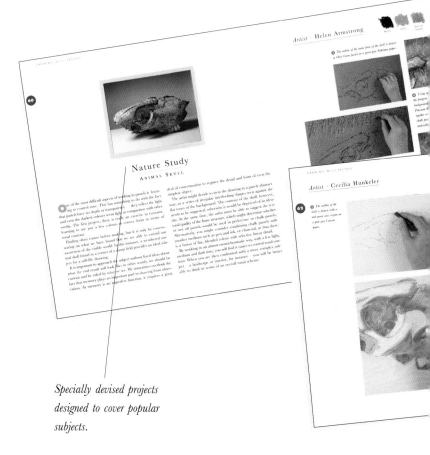

Specially devised projects designed to cover popular subjects.

CECILIA HUNKELER is a Swiss children's illustrator who works mainly in pastel, wax crayon, and gouache. Her technique involves a process of continually scraping back color and correcting the drawing so that the finished work has a kind of "carved-out" appearance. Apart from her illustration work, she is interested in still-life pastels and woodcuts. She has had a number of exhibitions in Switzerland.

SOPHIE MASON trained as a painter and has had a number of exhibitions in London and elsewhere. She is particularly concerned with the effects of light and color, especially in landscape. She works mainly in pastel when drawing landscape subjects directly from observation, sometimes combining the medium with watercolor, gouache, and pencil.

Techniques and methods explained clearly and precisely with easy-to-follow text.

Color palettes presented with every project.

Clear step-by-step photographs show the artist at work.

Each project is painted by three different professional artists.

Inspiring "critique" spreads compare different approaches and interpretations.

Practical problems highlighted by the author.

Helpful tips and advice given by top professional artists.

Results judged by the author, based on sound visual judgement and practical good sense.

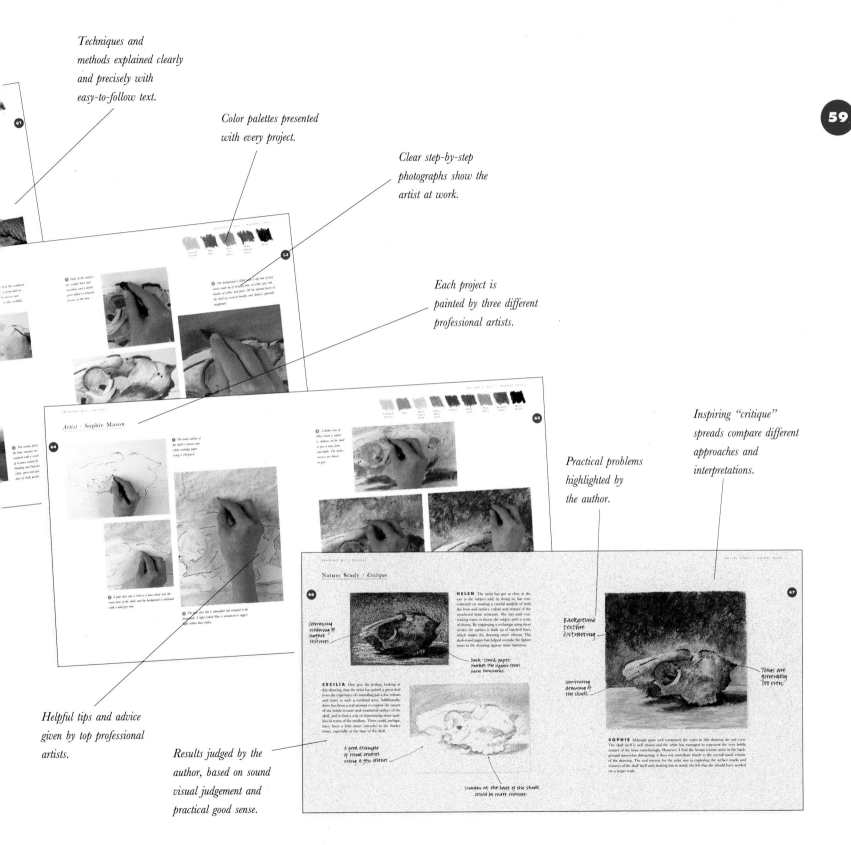

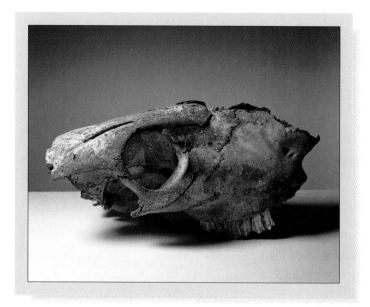

Nature Study

ANIMAL SKULL

One of the most difficult aspects of working in pastels is learning to control tone. This has something to do with the fact that pastels have no depth or transparency — they reflect the light, and even the darkest colors seem light in comparison with other media. The first project, then, is really an exercise in restraint, learning to use just a few colors to convey form in terms of tonal contrast.

Finding often comes before making, but it is only by concentrating on what we have found that we are able to extend our awareness of the visible world. In this instance, a weathered animal skull found in a corner of a damp field provides an ideal subject for a still-life drawing.

It is important to approach the subject without fixed ideas about what the end result will look like; in other words, we should be curious and be ruled by what we see. We sometimes overlook the fact that memory plays an important part in drawing from observation. As memory is an imperfect function, it requires a great deal of concentration to register the detail and form of even the simplest object.

The artist might decide to treat the drawing in a purely abstract way, as a series of irregular interlocking shapes seen against the flat tones of the background. The contour of the skull, however, needs to be suggested – otherwise it would be deprived of its identity. At the same time, the artist must be able to suggest the textural quality of the bone structure, which might determine whether or not oil pastels should be used instead of chalk pastels. Alternatively, you might consider combining chalk pastels with another medium such as pen-and-ink, or charcoal, so that there is a fusion of flat, blended color with selective linear detail.

By working in an almost monochromatic way, with a few light, medium, and dark tints, you will find it easier to control tonal contrast. When you are then confronted with a more complex subject – a landscape or interior, for instance – you will be better able to think in terms of an overall tonal scheme.

Artist • Helen Armstrong

BLACK	GRAY	YELLOW OCHER	OLIVE GREEN	YELLOW OCHER TINT	LIGHT CHROME GREEN	DARK CHROME GREEN	PRUSSIAN BLUE

61

1 *The outline of the main form of the skull is drawn in Olive Green pastel on a green-gray Fabriano paper.*

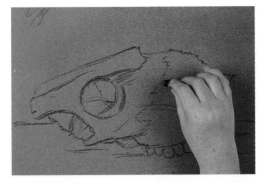

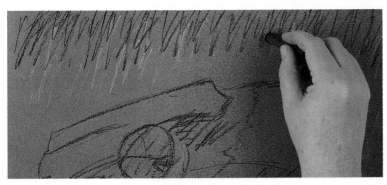

2 *The main areas of contrast are roughly sketched in with gray, olive, and black.*

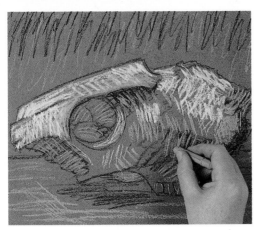

3 *The base colors of the skull — light ocher, light Chrome Green, gray with flecks of Yellow Ocher, and light Sienna — are applied with rapid short strokes.*

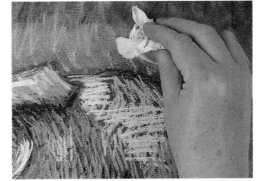

4 *Using a white chalk, patches of light are added to the foreground and to the top of the skull. The background is smudged with a tissue, and touches of Prussian Blue are added to all the areas of shadow, along with touches of gray and light ocher. Gray chalk pastel is also used for the reflected light on the underside and inside parts of the skull.*

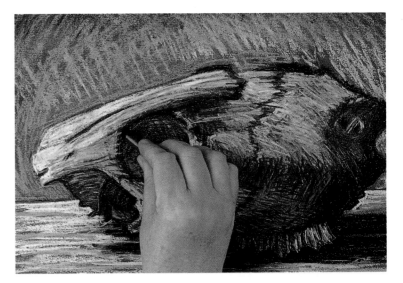

5 *The brittle and sharp edges of bone are drawn with Olive Green and dark Chrome Green. The highlights were toned down with gray in the foreground and gray and light ocher on top of the skull. The tonal balance was created using Olive Green and black.*

Artist • Cecilia Hunkeler

62

① *The outline of the skull is drawn with a mid-green wax crayon on a pale gray Canson paper.*

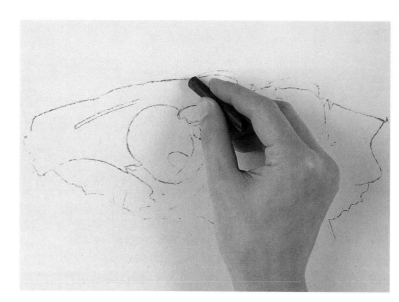

② *A pale Sap Green pastel is added to the weathered surfaces of the bone, and this is partly overworked in white. A darker gray is drawn in the recesses and reduced with a damp brush. White is also scribbled into the foreground area.*

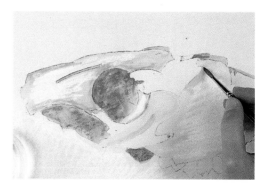

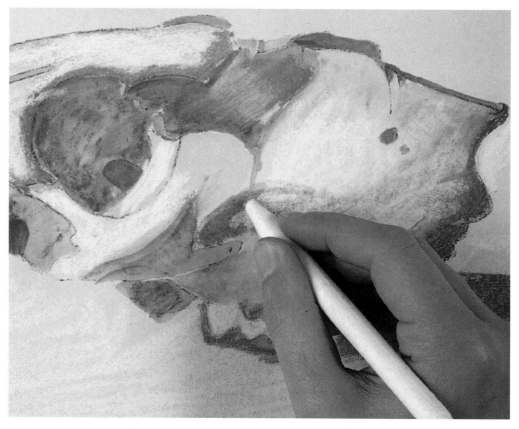

③ *The various facets of the bone structure are rendered with a variety of textures, created by blending and burnishing white, green, and gray tints of chalk pastels.*

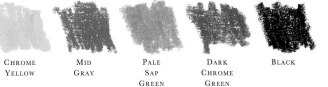

| CHROME YELLOW | MID GRAY | PALE SAP GREEN | DARK CHROME GREEN | BLACK |

4 *Some of the surfaces are scraped back and reworked, and a darker green added to delineate fissures in the bone.*

6 *The background is filled with a soft tone of gray wash, made up of merging tones of white, gray, and touches of yellow and green. All the internal facets of the skull are resolved tonally, and shadows generally heightened.*

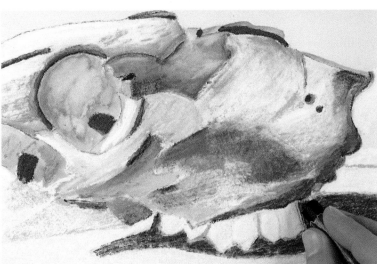

5 *The shadows at the base of the skull are drawn in charcoal and immediately fixed before adding dark tones of green to concave areas of the bone structure.*

Artist • Sophie Mason

1 *The main outline of the skull is drawn onto white cartridge paper using a 2B pencil.*

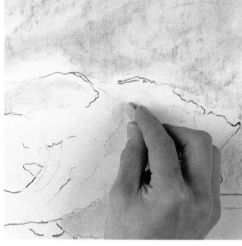

2 *A pale olive tint is laid as a base color over the main form of the skull, and the background is darkened with a mid-gray tone.*

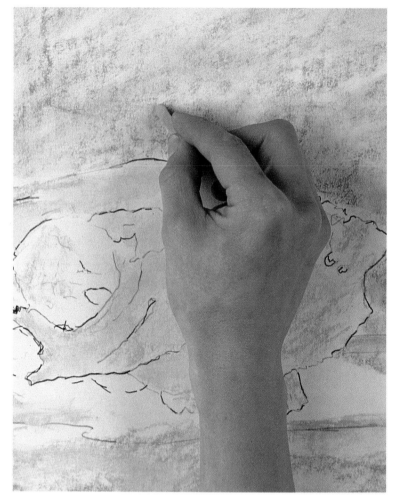

3 *The pale olive tint is intensified and extended to the foreground. A light Cobalt Blue is introduced to suggest light (rather than white).*

CADMIUM YELLOW	GRAY	MARS VIOLET LIGHT	COBALT BLUE LIGHT	VIOLET	DARK GRAY	PALE OLIVE	HOOKER'S GREEN	BLACK (PENCIL)

4 *A darker tone of Olive Green is added to shadows on the skull to give it more form and depth. The darker recesses are drawn in gray.*

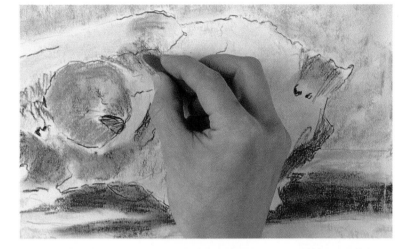

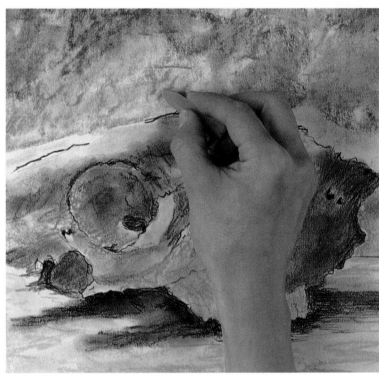

5 *The tonal contrast of the drawing is developed, adding more dark gray to the background and working around the contour of the skull with a light violet tint. More violet-purple and black soft pencil tones are applied to sharpen the edges of the skull, and to emphasize the brittleness of the bone structure.*

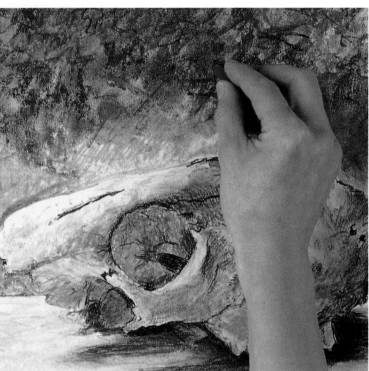

6 *Hooker's Green and dark gray are added to the background to increase tonal contrast with the foreground. Cadmium Yellow and dark olive are blended into areas of the skull, and a pale yellow tint is used to lighten the foreground. The balance of color and tone is resolved in the final stage.*

Nature Study · *Critique*

66

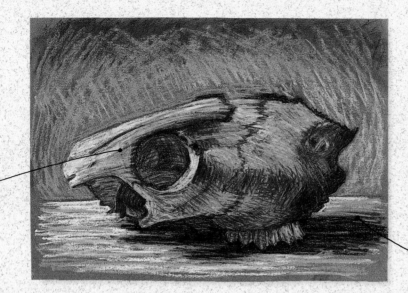

convincing rendering of surface textures

HELEN The artist has got as close as she can to the subject and, in doing so, has concentrated on making a careful analysis of the form, surface color, and texture of the weathered bone structure. She has used contrasting tones to invest the subject with a sense of drama. By employing a technique using short strokes, the surface is built up of hatched lines, making the drawing more vibrant. A darker, flat tone in the background would have produced more contrast and heightened the texture of the skull.

Dark-toned paper makes the lighter tones more luminous

CECILIA One gets the feeling that the artist has gained a great deal from controlling just a few colors and tones in such a confined area. Additionally, there has been a real attempt to explore the nature of the brittle texture and weathered surface of the skull. When representing both concave and convex surfaces, a careful modulation of tone is necessary to create the sense of depth and recession. By carefully blending chalk pastels one can achieve a gradual progression from light passages to dark.

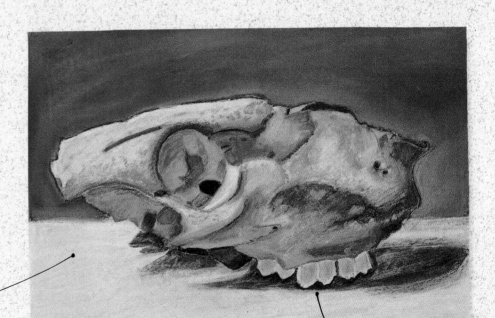

A good example of tonal control using a few colors

shadow at the base of the skull could be more intense

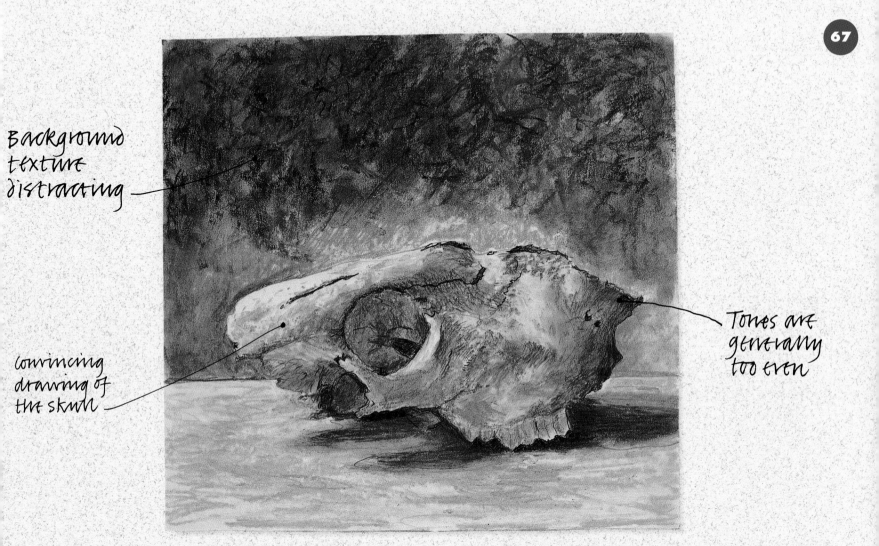

background
texture
distracting

convincing
drawing of
the skull

Tones are
generally
too even

SOPHIE Although quite well composed, the tones in this drawing are too regular. The skull itself is well drawn, and the artist has managed to represent the very brittle texture of the bone convincingly. However, I find that the broad texture used in the background does not contribute much to the overall tonal scheme of the drawing. The real interest for the artist was in exploring the surface marks and textures of the skull itself and, bearing this in mind, she felt that she should have worked on a larger scale.

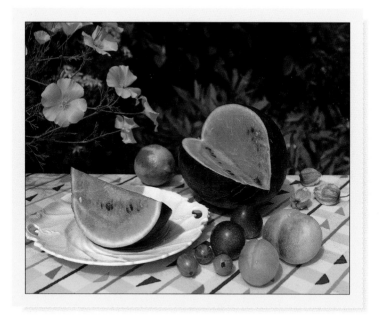

Still life

SUMMER FRUIT

After the restrained color and tone of the skull drawing, this project allows for a more profligate use of pure color. On the face of it, this still life of bright fruits would appear to be a fairly straightforward undertaking, since essentially it presents little more than an arrangement of elementary shapes. But the image could easily appear trite, unless careful consideration is given to color, contrast, and composition.

Sometimes it is necessary to exaggerate or heighten color contrasts in order to fully convey the inherent qualities of the subject – the juicy ripeness of the watermelon, for instance, or the bloom on the skin of the plums and peaches. The color of the fruit is complementary to the background foliage, and the yellow tablecloth divides the picture plane tonally.

How can you suggest the succulence of the fruit when working with dry chalk pastels? Should you use oil pastels instead, or perhaps mixed media? These are the kinds of questions you need to ask yourself before starting the drawing. Try a few initial experiments using some of the techniques described in the first part of the book. If you were using oil pastels, for instance, you could achieve greater transparency of color by burnishing the pigment with a finger moistened with white spirit. Alternatively, the surface can be scraped with a flat blade.

You may find that you need to work on the drawing in more than one session. If so, try to retain the spontaneity established with the first strokes. You might pace yourself by concentrating on the contours of the fruit and flowers in the first session, then by establishing the broad masses of color in the second session, before finalizing details in the last session.

Ultimately, the success of the drawing will depend on just how much you are prepared to invest in trying to uncover the specific values of each individual object, and the collective values of composition and color harmony.

Artist • Helen Armstrong

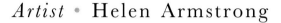

| YELLOW OCHER | CADMIUM ORANGE | GRAY | RED | SCARLET | YELLOW | DARK GREEN | COBALT GREEN | LEMON BLUE |

1 Oil pastels have been used for this project. The main outlines of the still-life group are drawn on a light gray Fabriano paper with pencil. Tints of mid- and dark green are scribbled into the background and on the gooseberries, lemon, and flower stalks.

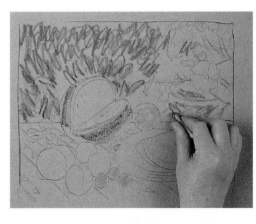

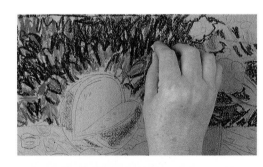

2 Parts of the background are blocked in with a soft black oil pastel.

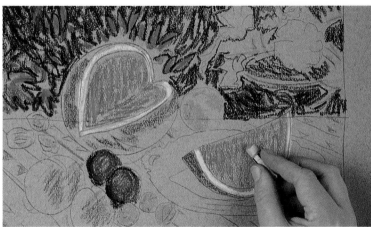

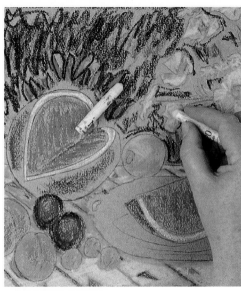

4 Yellows are now brought into the drawing – a Sennelier 20 and 22 on the tablecloth and flowers. A touch of orange is also added to the flower pods. Yellow Ocher is used to provide a darker tone on the peaches and for shadows on the cloth and lemon.

3 The reds are established at this stage – a pinkish red on the melon and peaches, a pink-brown on the plums, and pink for the pattern on the cloth. White and Lemon Yellow are fused together on the edges of the melon.

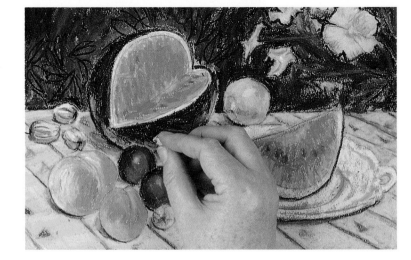

5 White (with a touch of lemon yellow) is used for the plate, and gray added to shadows. Traces of the background paper are allowed to show through. White highlights are added to the fruit. Black, Dark Green, and Dark Brown are fused together in the background to produce the dull tone of the leaves. Tones are now generally refined and moderated by adding light and dark touches of color, and by scraping back some areas and redrawing others.

Artist • Cecilia Hunkeler

70

1 *The outlines of the still-life group are drawn in a red wax crayon on a sheet of pale gray Canson paper.*

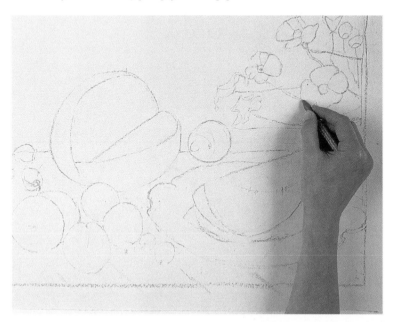

2 *The flowers, lemon, edges of the melon, and the tablecloth are drawn in Cadmium Yellow, which in turn is softened with a wet brush.*

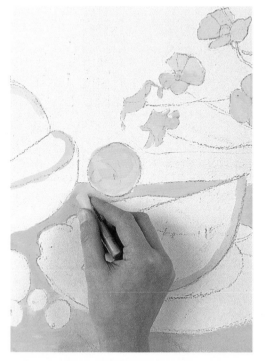

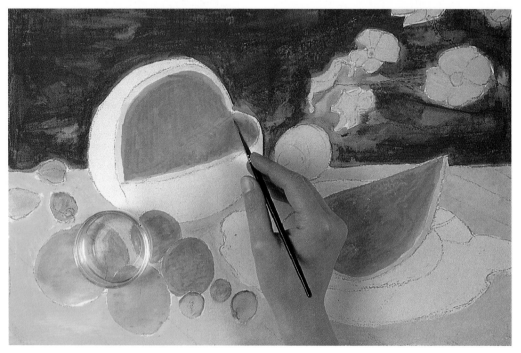

3 *Permanent Green Deep is worked into the background and on part of the fruit, and then reduced with a wet brush. Cadmium Orange is drawn on the peaches, plums, and melon, with touches of Scarlet Lake added before blending with a wet brush.*

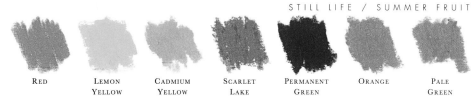

RED LEMON YELLOW CADMIUM YELLOW SCARLET LAKE PERMANENT GREEN DEEP ORANGE PALE GREEN

4 *A dark green tone is worked over the skin of the melon, and the red flesh is blended using a torchon, to produce a softer tone. The color of the other fruits is also intensified at this stage.*

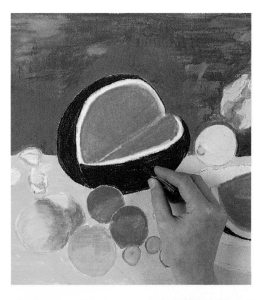

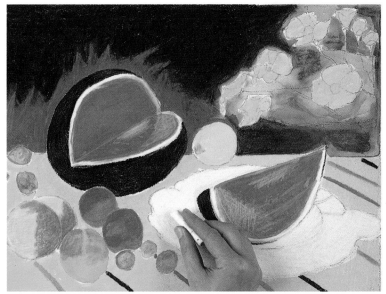

5 *The background is reworked, fusing together dark and light tones of green. Color on the fruit is scraped back and redrawn, and colored stripes are added to the tablecloth. A white chalk is worked over the plate.*

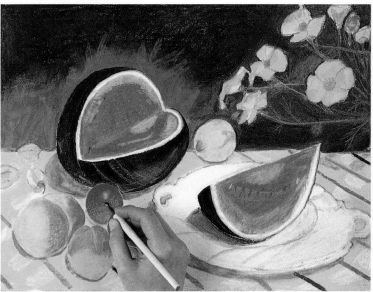

6 *The pitted texture of the fruit is rendered with the point of a scraping tool, using a stippling technique that exposes the paler tone beneath the top layer of color. Some white is worked into the flesh of the melon. The plate is resolved tonally and the flowers in the background redrawn.*

Artist • Sophie Mason

72

1 *A Raw Sienna pastel is used to mark out the main shapes of the still life, particularly in relation to the horizon line of the table.*

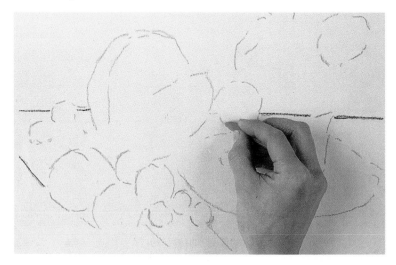

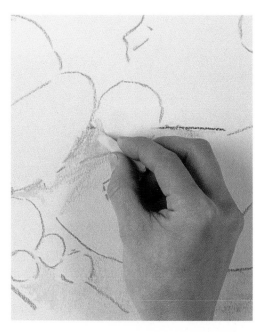

2 *Cadmium Yellow and Cadmium Orange are roughly scumbled into the foreground with a suggestion of the pattern on the tablecloth.*

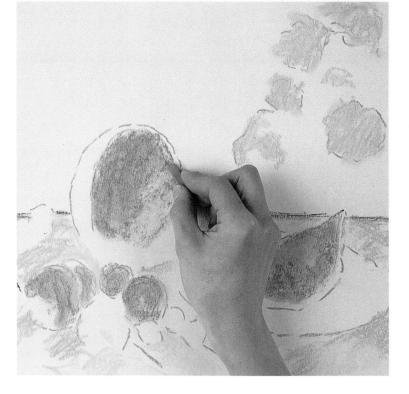

3 *Cadmium Red is used for the melon, peaches, and plums to give body to the main shapes in the arrangement and to provide contrast to the background. The flowers in the background are roughed in with Cadmium Orange.*

| CADMIUM YELLOW | CADMIUM ORANGE | YELLOW OCHER | RAW SIENNA | PERMANENT RED LIGHT | CRIMSON | PALE OLIVE GREEN | DARK OLIVE GREEN | MID GRAY | BURNT UMBER | 6B PENCIL |

4 *Burnt Umber is applied to the skin of the melon, and the background is darkened with Raw Umber.*

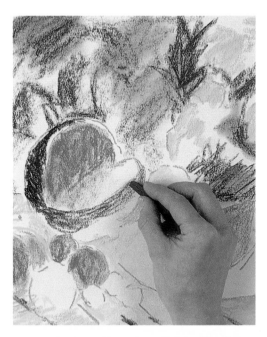

5 *Raw Umber and Burnt Umber are used to strengthen the background tone and to provide more definition to the flowers. Permanent red and light red are blended onto the peaches, melon, and plums. The outer shapes of the melon and plate are more carefully defined using graphite pencil and Burnt Umber.*

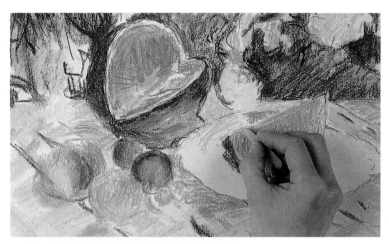

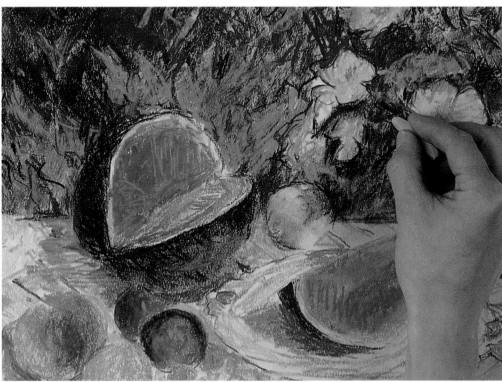

6 *Dark olive and pale olive are added to the background foliage to bring forward the shapes of leaves and to relate the background to the foreground. More gray is added to the plate. Greater definition is given to the flowers with Raw Umber and black pencil. Color reflected from the fruit is added to shadows using Cadmium Yellow and Yellow Ocher.*

Still life • *Critique*

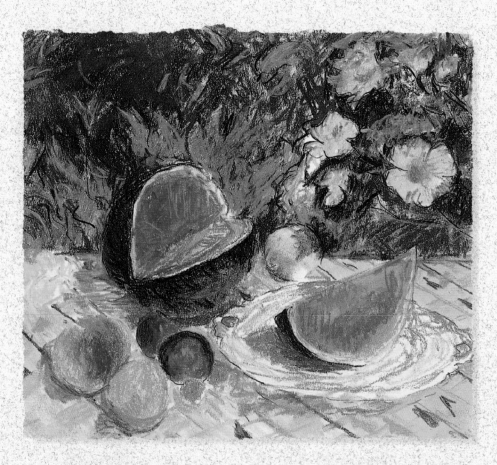

SOPHIE One senses that the artist enjoyed working with the brilliant colors demanded by this subject. The drawing works well in terms of color and tone, and in the rich variety of marks made with chalk pastels. This is a drawing that bears the imprint of an artist who works quickly, using short strokes of pastel, rather than slowly building up layers of color. Working in this way there are inevitably gains and losses, and in this instance some shapes have been more carefully defined than others.

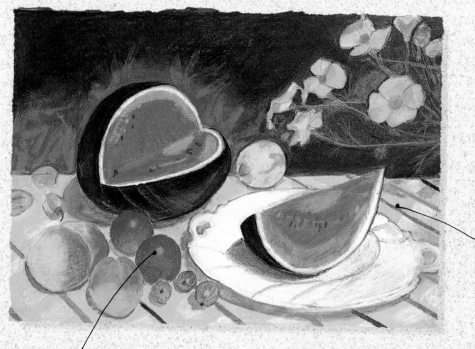

CECILIA The intensity of the color and the range of textures – from smooth to coarse-grained fruit skins – has been dealt with convincingly and, one senses, with enthusiasm! Contrasts of tone have also been handled well, although it is possible that the background could have been made darker, and the leaf forms made more distinct, without detracting too much from the strong color and shapes of the fruit. When so many elements in a drawing compete for attention, it is sometimes better to change the composition or point of focus.

contrasts of tone generally handled well – background could have been darker

Texture of the fruit skin rendered convincingly

The oil pastel impasto adds a tactile quality

HELEN The decision to use oil pastels rather than chalk pastels clearly paid off in this drawing. The clarity of strong shapes and the rich impasto of color lends a tactile quality to the work. The artist decided early on to try to retain the lucidity of the drawing and this has meant sacrificing something of the delicacy of the flowers. The fruit has a sumptuousness that is heightened by the dark tone of the background color. When drawing objects such as plates or cups and saucers seen in perspective, it is important to make sure that the ellipse is drawn convincingly.

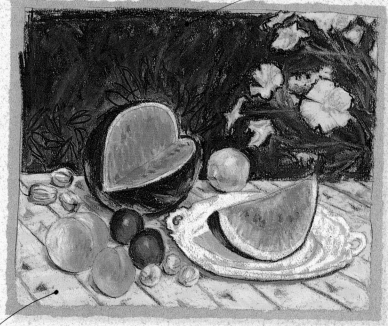

Dark tone of paper enriches color values

Garden Scene

DOVECOTE AND FLOWERS

Artists have long been inspired by gardens both formal and informal. Claude Monet, of course, is the supreme example – his garden at Giverny became the source of some of his finest work, including the series of paintings of waterlilies growing beneath a bridge. He realised that he could orchestrate color using difference species of plants and flowers to create an approximation of preconceived color schemes.

The subject selected for this project is an old garden attached to an English manor house, now largely destroyed by fire. The dovecote remains intact and its mellow stone provides an interesting contrast to the rich color and gossamer-like quality of the abundance of flowers in the foreground.

Composition can be critical in dealing with this kind of subject, since you have to try simultaneously to express the dynamism of growth and the solidity of the stonework. Too much concen-

tration on isolated details might lose the sense of actuality and liveliness. Working with pastels, you are less likely to get bogged down with the precise details of individual flower heads and will be able to concentrate instead on treating everything in terms of planes and color masses. Contrast, too, plays an important part: the intensity of the color of the flowers is heightened by seeing them against the darker tone of the hedge, for example, and the dovecote is defined by the darker tones of adjacent foliage.

Of course, you are continually having to make adjustments to the color and tone of a drawing as it progresses from one stage to another. A flat tone that appears dark when first laid might seem much too light when other colors have been added. The rich, red tone of a flower head might sink into a neutral background tone, whereas a sharply contrasting, complementary dark green would make it appear even richer.

Artist • Helen Armstrong

BLACK BURNT SIENNA DEEP YELLOW LIGHT YELLOW GOLD OCHER PRUSSIAN BLUE BLUE VIOLET PERMANENT ROSE MADDER LAKE DEEP

❶ The basic composition is drawn sparingly in graphite pencil on a dark ocher sugar paper. White and Cobalt Blue are blended together in the sky.

❹ At this stage, the artist decided that the top half of the drawing had become too detailed. She therefore took the surface pigment off with a tissue, blurring the details. Greens were then rubbed into the foreground, followed by the sharper linear strokes for stalks and leaves using Olive Green, Chrome Green Light, and Chrome Green Deep. A Pthalo Green is also used. The flower heads are picked out in white, permanent rose, red violet, blue violet, scarlet, Madder Lake Deep, and Burnt Sienna.

77

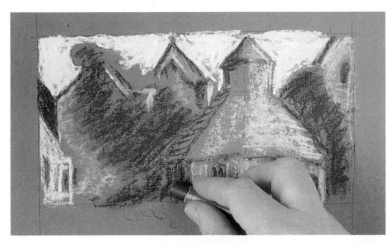

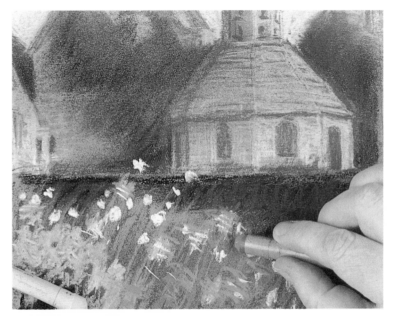

❷ The stonework of the buildings is drawn in a light Yellow Ocher, and the tone of the paper, which is darker, is allowed to show through in areas of shadow. Prussian Blue is used as an undertone for the foliage.

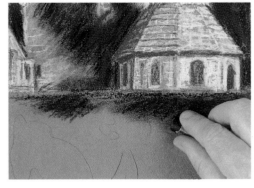

❸ More detail is added to the stonework, using a light Yellow Ocher for lighter tones and Olive Green for shadows. Olive Green, Chrome Green Deep, and black are fused together on background foliage.

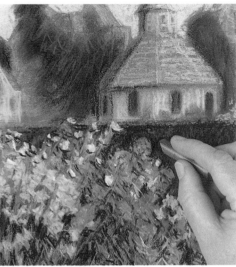

❺ A black chalk is now used to bring the drawing together as a single statement, working in tones between stalks in the foreground and adding detail to buildings in the background. Finally, the orange roses are highlighted with Gold Ocher and Burnt Sienna.

SCARLET CHROME GREEN DEEP OLIVE GREEN CHROME GREEN LIGHT GRAY COBALT BLUE YELLOW OCHER YELLOW OCHER TINT

Artist • Cecilia Hunkeler

78

1 *An outline drawing of the main shapes is made with a mid-green wax crayon on a sheet of off-white cartridge paper.*

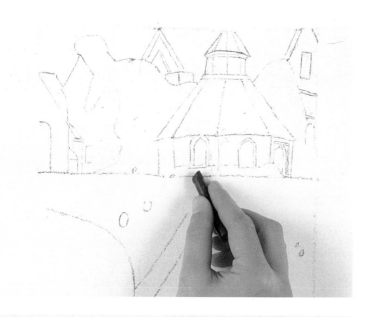

3 *A stippling technique is used for the flowers using pink, Geranium Red, vermilion, Lemon Yellow, Yellow Ocher and Violet Dark.*

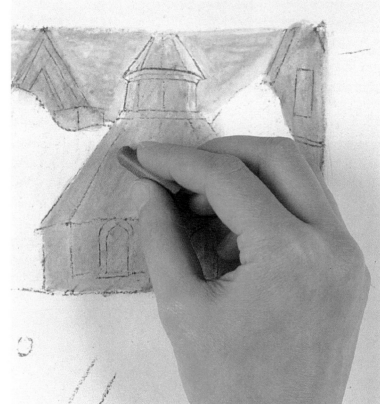

2 *A mid-gray pastel is worked roughly over the sky and blended with Burnt Sienna and a touch of yellow on the dovecote and other buildings.*

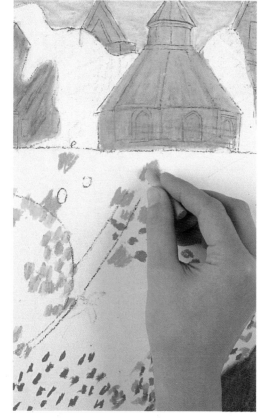

| MID GREEN | MID GRAY | LEMON YELLOW | YELLOW OCHER | VERMILION | VIOLET DARK | BURNT SIENNA | BLACK |

4 *A thin layer of Permanent Green Light is applied over the whole of the garden area, and this is reduced to a transparent tone with a moist sable brush, which allows previous colors to show through.*

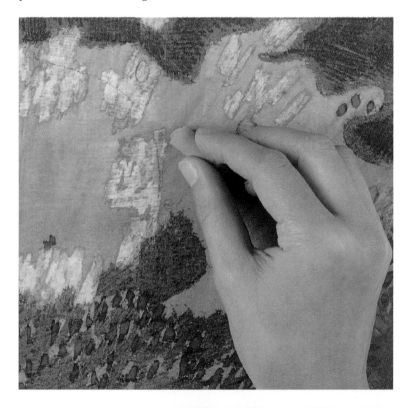

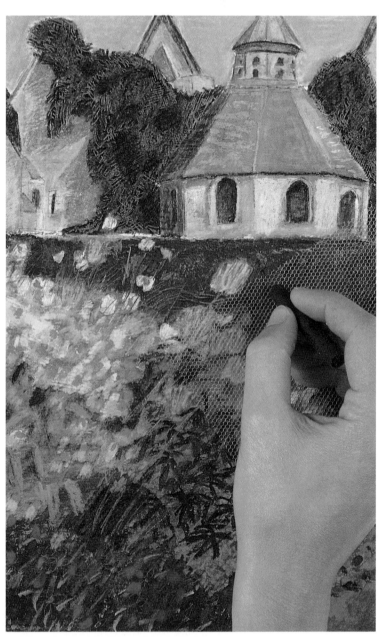

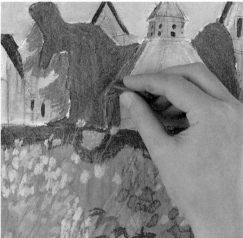

5 *More flowers and leaves are stippled in, and the darker recesses of the buildings are drawn in Burnt Sienna blended with black.*

6 *In the final stage, the textural quality of the drawing has been enriched by a combination of scraping out leaf shapes with a steel nib, and by forcing color through a piece of gauze mesh. The drawing is resolved in terms of color and tone and without a conspicuous outline.*

Artist • Sophie Mason

80

1 *A green-brown Ingres pastel paper was selected for this subject in relation to the overall color scheme. The dovecote and the main position of the flowers are briefly stated in Olive Green pastel pencil.*

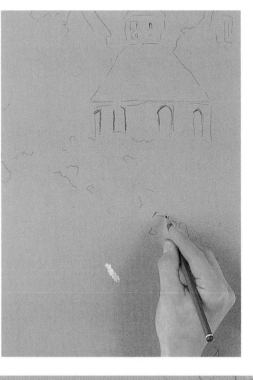

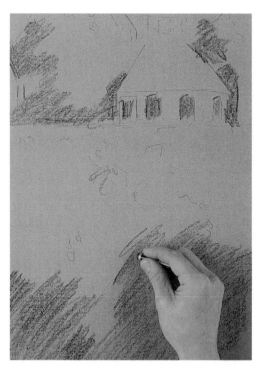

2 *A dark gray crayon (water-soluble) is spread over the foreground and in the darker areas of the background.*

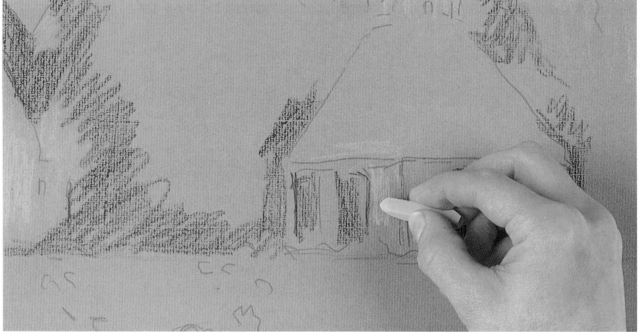

3 *Touches of pale olive are added to the dovecote and foreground.*

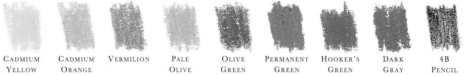

| CADMIUM YELLOW | CADMIUM ORANGE | VERMILION | PALE OLIVE | OLIVE GREEN | PERMANENT GREEN | HOOKER'S GREEN | DARK GRAY | 4B PENCIL |

4 Permanent Green is overlaid on the areas of foliage in the background and carried through to other parts of the garden. Touches of gray are added in other areas.

5 The flowers are stippled in with various colors, including Cadmium Yellow (oil pastel), Permanent Red, Cadmium Orange, vermilion, and pink (chalk). A soft pencil is also used to bring more definition to the drawing.

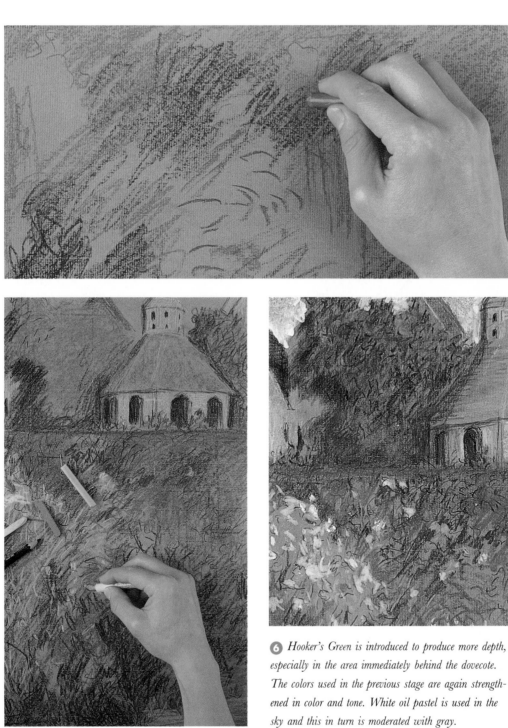

6 Hooker's Green is introduced to produce more depth, especially in the area immediately behind the dovecote. The colors used in the previous stage are again strengthened in color and tone. White oil pastel is used in the sky and this in turn is moderated with gray.

Garden Scene • *Critique*

The general mood well interpreted

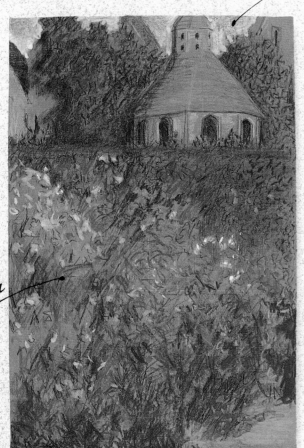

There is little tonal progression from light to dark – from the path to the distant buildings

HELEN Halfway through this drawing, the artist realized her mistake in developing the top part of the composition at the expense of the rest of the drawing. You should always consider the drawing as a whole and not concentrate too much on one area. In this project, the artist's primary interest lay in the way that the bright color of the flowers contrasted with the dark tone of the hedge. The early attention to architectural details detracted from this, which is why she wiped the surface pigment away in order to simplify the background. One must always be prepared to spoil things a little in order to gain ground. In this instance, you can see how, in the final stage of the drawing, the artist has managed to resolve the tonal balance of the drawing in a way that draws attention to the garden flowers, rather than focusing on background detail.

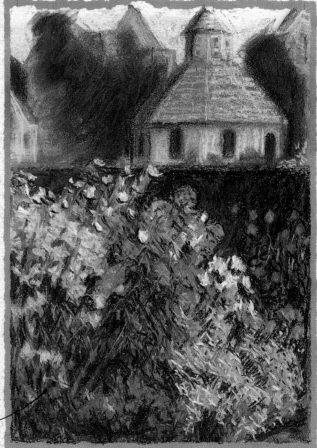

SOPHIE The artist herself felt that the choice of such a dark-toned pastel paper was a mistake – although I would disagree, since I feel it allows the richness of color to become more evident in the final stage of the drawing. I like the general mood, atmosphere, and sense of place that comes across. The flowers are shown *en masse* without any fussy detail, and this works well in contrast to the solidity of the stone dovecote in the background. I do feel, however, that tonally everthing is too even. Could the tone beyond the dovecote have been made darker? Or the path and flowers in the immediate foreground lighter in tone?

Everything has been resolved in terms of tonal balance

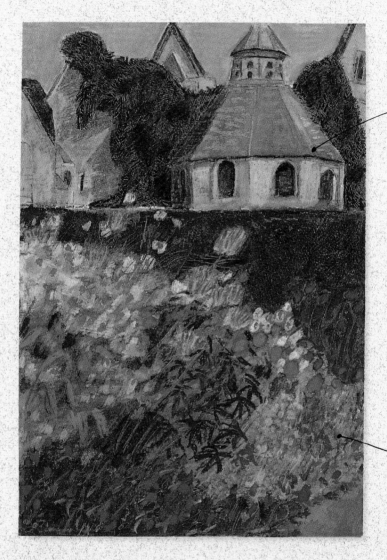

The sky should have been extended to show the complete shape of the dovecote tower

Intelligent combination of oil and chalk pastels to give a variety of texture

CECILIA The artist has gone to considerable lengths to recreate the textural contrasts of weathered stone and the delicacy of the flowers, creeper, and hedge. She has used a combination of oil and chalk pastels, to work and rework some parts of the drawing and rebuilt it in her own terms. Contrasts of color and tone work without being too boldly defined. Compositionally, it might have been interesting to extend the path in the foreground.

All three artists have cropped off the top of the tower of the dovecote, which I feel is unnecessary. Preliminary thumbnail sketches can help to avoid this kind of problem.

Figure Study

BALLET DANCER

Thanks to Degas, ballet dancers and the pastel medium are now inextricably linked. It is, of course, always difficult to deal with any theme or subject that has been exhaustively explored by a well-known artist, particularly when that artist is a master draftsman like Degas. However, you should always try to assess any subject from your own individual standpoint.

The pose itself, for instance, I would suggest, is unlike any pose Degas would have selected. The slightly self-conscious attempt by this ballet student to adopt a "typical" ballet pose would have appeared too contrived for Degas, whose intent was to express movement. Nevertheless, there are interesting aspects of the pose that call for consideration: the head in profile tucked into the right shoulder, and the way that the linked arms encircle the folded legs of the dancer.

The mind delights in unity, and, with this pose, there is a need to try to connect the various parts of the body together by positively stated accents and, where we allow the line to be broken, by inference. The yellow-brown tone of the pine floor provides a useful ground color against which the white of the dancer's costume can be clearly defined.

Above all, the drawing needs to work as a single statement. To achieve this, you need to be aware of both positive and negative shapes and the subtle variations of tone that suggest volume and describe the form. If, for example, the color of the floor area were to be too light or dark in tone, or the texture too pronounced, this would detract from the form of the figure itself. Again, if the figure is placed too symmetrically within the composition, it will be uninteresting.

Artist • Helen Armstrong

BURNT SIENNA BURNT UMBER GOLD OCHER CARMINE NAPLES YELLOW GRAY YELLOW OCHER BURNT SIENNA TINT YELLOW OCHER TINT

85

1 *Using a hard pencil, the main outlines are drawn on a buff-colored Ingres paper.*

2 *The pale yellowish tones of the pine floor are drawn with dark and light Yellow Ochers and touches of Burnt Sienna.*

3 *Flesh tones are added to the face, neck, and arms, using short strokes of Burnt Sienna, Gold Ocher, light Burnt Sienna, and flecks of carmine.*

4 *At this stage, all the white areas are drawn in, using touches of mauve, gray, and Naples Yellow as well as white. The floor is also made lighter in tone to the left of the figure.*

5 *The hair is drawn in Burnt Sienna and Burnt Umber with touches of Gold Ocher. Areas of shadow are defined with Burnt Sienna and Burnt Umber. More detail is added to the floorboards.*

Artist • Cecilia Hunkeler

86

1 *A faint outline of the figure is drawn with a red wax crayon on a sheet of pale gray Canson paper.*

2 *A strong tone of Cadmium Yellow is worked around the figure, and over the whole background area. A tint of Indian Red is overlaid in patches, following corresponding accents around the contours of the seated figure. White chalk is used to suggest the frills of the tutu.*

3 *A Raw Umber is applied as a dark tone for the hair and, used more sparingly, to follow the rounded form of the arms. The color is then softened slightly with a wet sable brush.*

VERMILION CADMIUM
YELLOW YELLOW
OCHER DEEP
OCHER RAW
UMBER INDIAN
RED
LIGHT INDIAN
RED

5 *In the final stage, the contrasting skin tones are smoothly blended. A pale pink hue is used to soften the tone of the bodice, tutu, and tights. Shadows around the form are intensified and pale tints on the figure again carried into the background.*

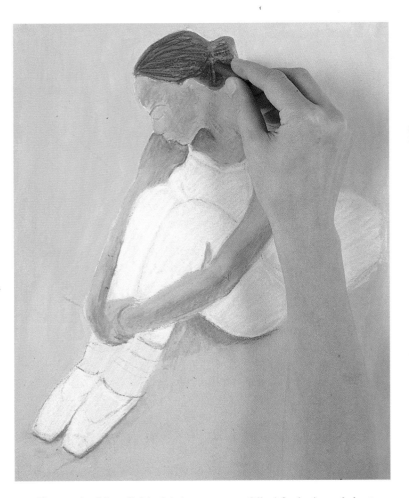

4 *The strands of the pulled-back hair are more carefully defined using a darker tone of Raw Umber. Flesh tints are added to the face and arms, and the same tints carried through to the background.*

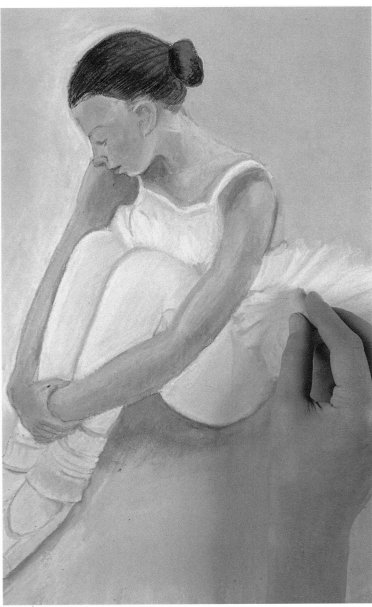

Artist • Sophie Mason

1 *The main form of the figure is sketched on a pale cream paper using a graphite pencil and a Burnt Umber pastel pencil. A few directional lines for the floorboards are also indicated using the same pencil.*

2 *A warm flesh tint of Permanent Red is added to the arms and face, and a gray pastel used to redraw the contours of the figure.*

3 *The background is roughly scumbled in with a Naples Yellow pastel.*

| RAW SIENNA | CADMIUM YELLOW | 6B PENCIL | NAPLES YELLOW | YELLOW OCHER | MARS VIOLET LIGHT | VENETIAN RED | PERMANENT RED | BURNT UMBER | GRAY |

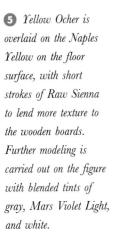

4 *Mars Violet Light is used to suggest shadows mainly on the figure and on the tutu. A white is introduced for highlights and a Venetian Red for the hair and neck.*

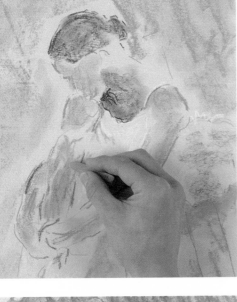

5 *Yellow Ocher is overlaid on the Naples Yellow on the floor surface, with short strokes of Raw Sienna to lend more texture to the wooden boards. Further modeling is carried out on the figure with blended tints of gray, Mars Violet Light, and white.*

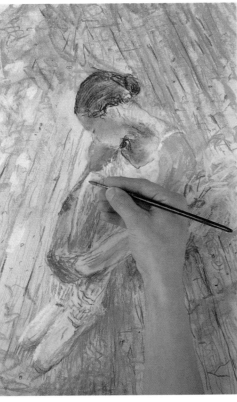

6 *Contours are redefined and accents strengthened. Burnt Umber and olive pastel pencils are used to bring out the grain of the floorboards. Finally, touches of white and Cadmium Yellow gouache are mixed and painted in short strokes on the left-hand side of the drawing to suggest space and light.*

Figure Study • *Critique*

90

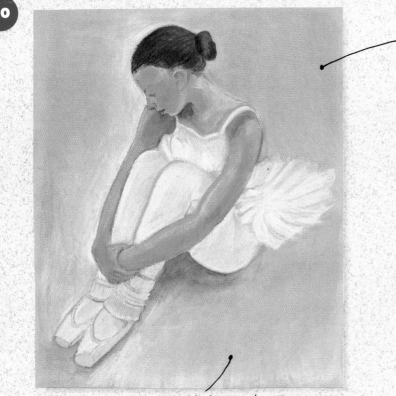

The spontaneity of the drawing maintained in the final stage

CECILIA The artist obviously made a decision from the outset to leave out all the directional lines of the floorboards, which she felt were too distracting. The overall lightness of the subject has been carefully controlled in terms of the medium.

In this pose the head of the dancer turns into the shoulder of the right arm. In this rendering, however, the actual tilt and the shape of the head, could have been more carefully observed.

overworked floor texture

HELEN It had been the artist's intention to allow more of the colored paper to show through the drawing. In the final stage, however, the floor has been overworked to a degree where the pattern of strong directional strokes interferes with the more delicate rendering of the figure itself. However, the spontaneity and freshness of the drawing of the figure has been maintained right through to the final stage.

This is an example where more consideration given to contrasting coarse and smooth textures, dark and light tones, would have improved the drawing considerably.

The final stage of the drawing is perhaps too refined

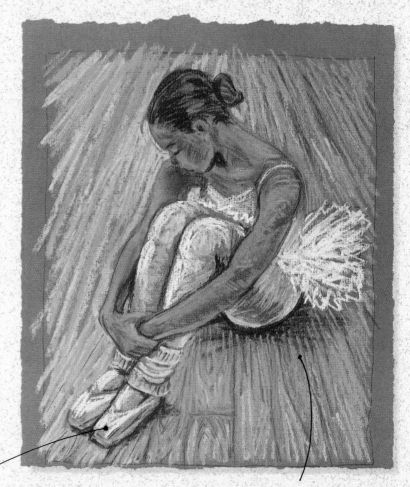

careful control of light and shade

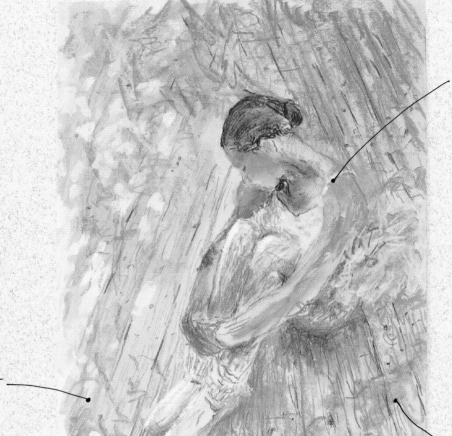

skilful handling of the form of the dancer

Floor texture has been OVERSTATED and attracts from the figure

More consideration should have been given to the placement of the figure within the overall composition

SOPHIE The figure is lost to some extent in the rendering of the surrounding floor texture. This could have been avoided by using stronger contours when drawing the figure itself, or by greater tonal contrast. Having said that, parts of the figure have been drawn with a degree of skill and sensitivity to the subject. More consideration should have been given to the composition, especially the placement of the figure within the spatial dimension of the room, and to avoid cropping the dancer's tutu.

Architecture

WEATHERBOARD HOUSES

At one time, it was possible to determine the geological features of a region by the variety of stone or timber used in the construction of domestic and religious architecture. Today, however, corporate methods of "system" building have largely blurred the differences between one place and another. Nevertheless, there are still pockets of decaying or restored buildings in most towns or villages, which remind us of the uniqueness that once distinguished, say, San Francisco from Detroit or New Orleans from Boston.

Nostalgia is one of the deepest of human sentiments, and we are sometimes drawn to the style and elegance of 18th- and 19th-century classicism. We might be visually stimulated by vintage movie theaters and hotels as well as warehouses and bridges, but often it is the sheer contrast and variety of a town or city that appeals to an artist.

This project concentrates on the charming weatherboarded houses that line a sleepy sidewalk in a small town in Georgia. Each house is different in design, yet all reflect the high standards of craftsmanship of builders at the turn of the century.

All architectural subjects demand contrast; three-dimensional qualities are best expressed by the way that light can sharply define some surfaces, while others remain in deep shadow. For this reason, you might need to wait for the right season and a certain time of day to get the best out of the subject. You might try making several studies in varying weather conditions.

It is difficult to render detail with sticks of chalk or oil pastel; one might therefore consider using sharpened pastel pencils on top of broader areas of color. Alternatively, the scene might be interpreted in a form of rapid notation that hints at detail rather than registers every brick, tile, or window pane.

Artist • Helen Armstrong

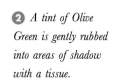

| COBALT BLUE | ULTRAMARINE | BURNT UMBER | BURNT SIENNA | YELLOW OCHER | GRAY | BLACK | OLIVE GREEN | DEEP CHROME GREEN |

1 The outlines of the houses and some architectural detail is drawn in graphite pencil on a thin gray pastel paper. The sky is first drawn in white, and then with patches of Cobalt Blue and ultramarine, which are blended with the white.

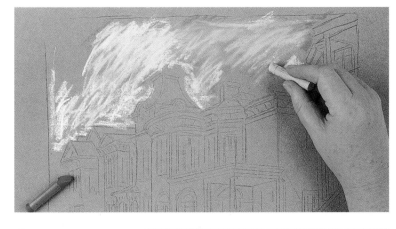

2 A tint of Olive Green is gently rubbed into areas of shadow with a tissue.

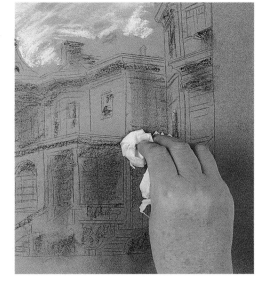

3 The brickwork is represented using a blended tone of Burnt Sienna and Gold Ocher. Burnt Umber is added for shadows on the bricks and for roof tiles. A light gray is used to highlight the lighter tones in shadows (the gray of the paper being darker in tone).

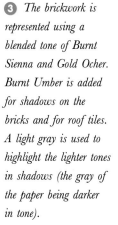
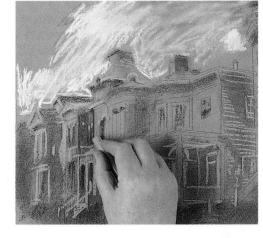

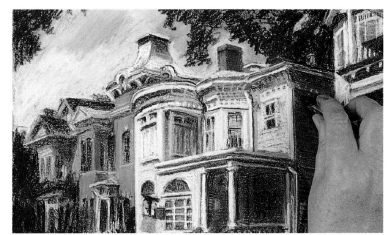

4 The white of the weatherboard building is picked out at this stage with chalk pastel. A pale gray is added for recesses and shadows. The tone of the paper is allowed to work as a color.

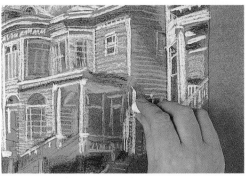

5 More work is carried out on the sky, by blending blue and adding a softer white for clouds. This, in turn, is made slightly warmer with some pale Yellow Ocher. The sky was sprayed with fixative at this stage. The trees are drawn with layered tones of olive, Chrome Green, and black. Black and gray are added to areas of shadow on the buildings. Some pencil lines are added for emphasizing architectural detail. Elsewhere, some detail that had been overworked is canceled out. The foreground is extended slightly. Finally, the white of the central house is warmed with a touch of Yellow Ocher.

Artist • Cecilia Hunkeler

94

1 *The main outline of the houses is drawn in blue crayon onto a gray-green Canson paper.*

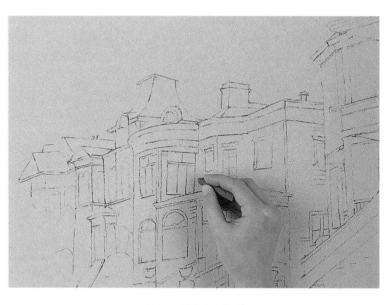

2 *A rich vermilion is worked into the façade of the house on the left, and the same color carried through to details on other houses. The basic greens of the tree foliage are drawn in contrasting tones of Olive Green on the left and a Dark Chrome Green on the right.*

3 *An off-white tone is worked into the façades of the central house and the adjacent house on the far right. A pale, light brown tint provides a half tone in the shadows. More tones are added to the foliage and to the house on the far left. Some of the darker recesses of the windows are drawn in charcoal gray.*

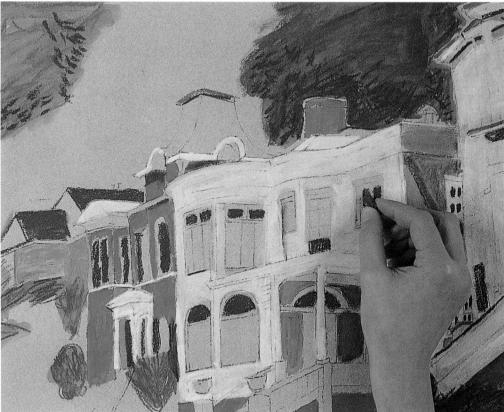

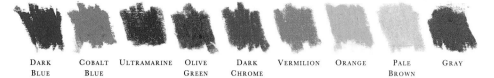

DARK
BLUE

COBALT
BLUE

ULTRAMARINE

OLIVE
GREEN

DARK
CHROME
GREEN

VERMILION

ORANGE

PALE
BROWN

GRAY

4 *Blended tones of ultramarine and Cobalt Blue are added to the sky at full strength and overworked with white chalk for the clouds on the left. The color of the façade of the red house is modified by working over the vermilion with gray and orange. White chalk is used to restate the window frames and the wooden supports to balconies and canopies.*

5 *All the decorative architectural details under the eaves, windows, porches, stairs, and so on, are now added. The weatherboarding is picked up in successive strokes of white, cream, and gray. The foliage is more carefully defined and colors in the sky softly blended.*

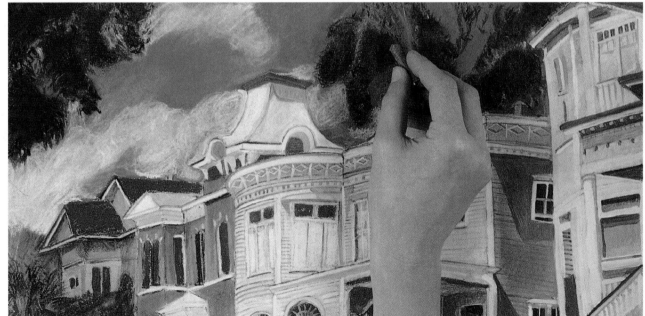

Artist • Sophie Mason

1 *The main structure of the buildings is drawn directly on white cartridge paper with a pencil and gray crayon.*

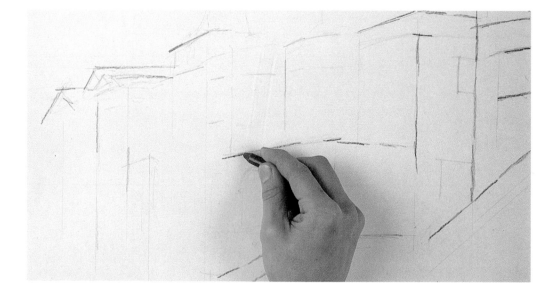

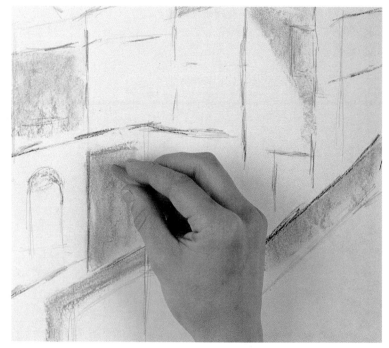

2 *A light mauve is selected as a mid-tone to establish the shadows in all the recesses, such as doorways, eaves, balconies, and so on.*

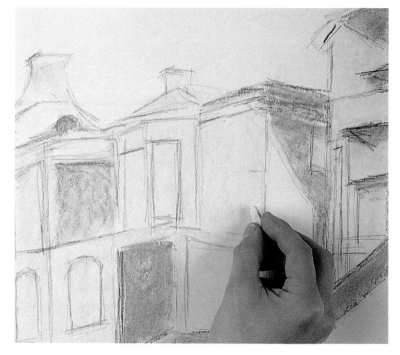

3 *Naples Yellow is spread thinly over the buildings to suggest sunlight and to contrast with the cooler lilac hue. The drawing is restated in pencil.*

NAPLES YELLOW	MARS VIOLET LIGHT	PERMANENT RED LIGHT	PURPLE	CERULEAN BLUE LIGHT	OLIVE GREEN	HOOKER'S GREEN	DARK GRAY

97

4 *The warm tones are intensified with Permanent Red Light. Darker tones of violet are added to shadows, and gray to windows and the eaves of the building.*

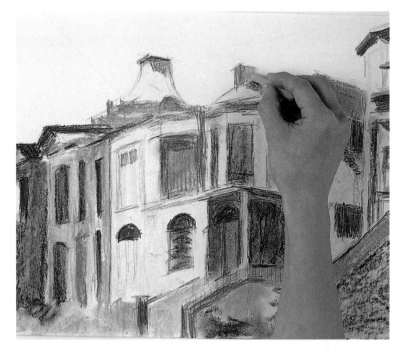

6 *Cerulean Blue is scumbled into areas of the sky, and is also blended with the foliage and on parts of the windows. A gray pastel is used to draw the weatherboard structure of the wooden building. Olive Green is added to the trees.*

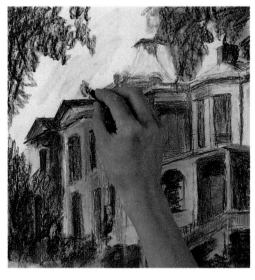

5 *Mars Violet Light provides a pale shadow, which is blended with other colors. Hooker's Green is loosely drawn into the foliage, and some Burnt Umber is added to areas in shadow.*

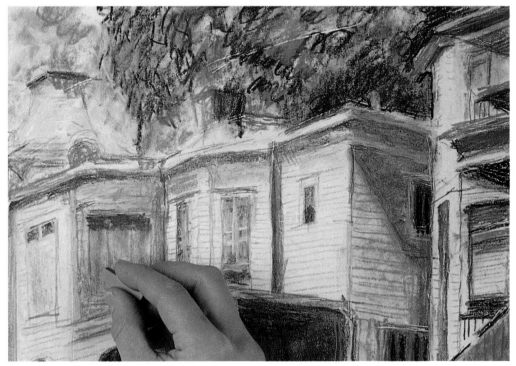

Architecture · *Critique*

successfully evokes the brilliance of southern light

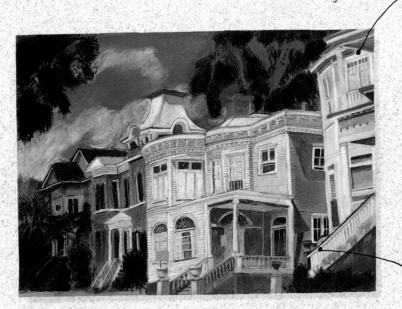

CECILIA In this project, the artist has decided to treat the subject in a lyrical way, by transgressing the conventions of perspective – and by bringing decorative and rhythmic qualities to the fore. Again, by heightening color values, she evokes the brilliance of a southern light. By working on a fairly large scale (20in x 14in), she has been able to relate everything to a basic pattern of interlocking lines, shapes, and color. In this way, she has been able to say much more about the intrinsic qualities of the scene than would have been possible in a more matter-of-fact rendering.

Basic patterns and decorative values have been heightened

Branches of trees could have been left out

HELEN In this drawing, the artist has been concerned primarily with the effects of light and shade; architectural detail has been subordinated to a basic tonal scheme. By restricting the number of colors used, she has been able to exercise more control over the structure of the drawing. The gray tone of the paper has been integrated into the overall tonal scheme. I feel that the branches of the trees on the left-hand side of the drawing could have been omitted. On the whole, however, the balance between color, tone, and descriptive detail has been judged very well.

I find that it is always helpful when dealing with architectural subjects to view the scene from different standpoints. All too often one settles for a kind of middle-distance view, without considering the way that scale can dramatically invest a drawing with interest.

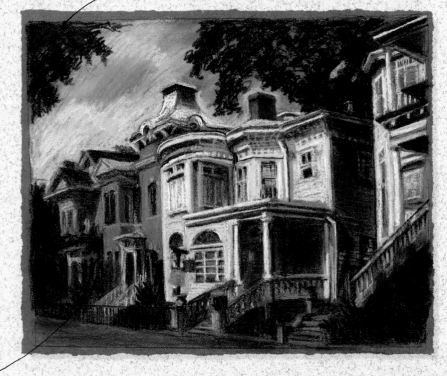

Well-judged balance between color, tone, and descriptive detail

composition is
awkward - more
of the foreground
could have been
included

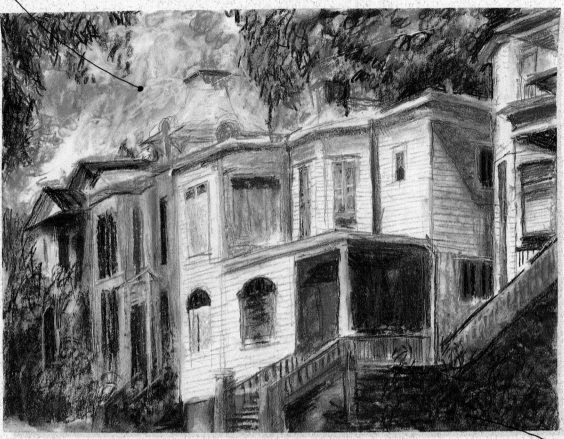

good feeling for
atmosphere and
sense of place

SOPHIE Detailed architectural subjects are always difficult to render in terms of a broad medium such as chalk or oil pastels. At most, you can only hint at details such as decorative awnings and porticoes, sash windows, grandiose balconies, and other intricate details. Here, the artist has managed to suggest the grandeur of the period houses without resorting to laborious detail. She contrasts cool violet and blue with brick red and Naples Yellow to convey something of the atmosphere of this dormant southern suburb.

More attention should have been given to the basic structure of this drawing: the simple interlocking proportions of the basic building shapes seen in perspective. I feel that the composition is rather uneasy, and the displeasing truncation of the houses might have been avoided by including more of the foreground.

Portrait

SRI LANKAN WOMAN

When an artist produces a portrait that is pleasing to the sitter and their family and friends, it is usually claimed that he or she has captured a "likeness." But a "likeness" is difficult to define since it is dependent on a variety of intentions, both on the part of the artist and his or her subject. Most people refer to a "likeness" as being in some way emulative of the silky sheen of a photographic print; yet such portraits, although technically sound, are often lacking in conviction. The artist who is anxious to please the sitter frequently neglects other values. A good portrait, I believe, goes beyond external appearances to suggest something of the inner life of the sitter.

The old Sri Lankan woman selected for this portrait, for instance, has spent a lifetime working in tea plantations. Her life experiences appear to be etched into her weathered features. Her expression is proud – a spirit unbroken, defiant. One senses a fine intelligence, that this old lady is a fount of wisdom, and is ready to pass it on to a younger generation. All these qualities should be apparent in any subsequent portrait.

Technically, it could be treated almost monochromatically, using just three or four tones of pastel of the same hue. The tones are strongly contrasted, and the merging of light areas into dark needs to be handled carefully. Before starting the drawing in pastel, however, it is a good idea to make a series of thumbnail sketches in order to work out all the compositional variations and the main divisions of light and shade.

You might also consider using a toned paper, or staining the surface yourself with a tint that relates to your intended overall color scheme.

Artist • Helen Armstrong

BLACK GRAY VANDYKE BROWN BROWN YELLOW OCHER PALE ORANGE PINK PRUSSIAN BLUE GOLDEN YELLOW

1 *Oil pastels are used for this portrait. The outlines are drawn with a pale tint of Vandyke Brown on a black Fabriano paper.*

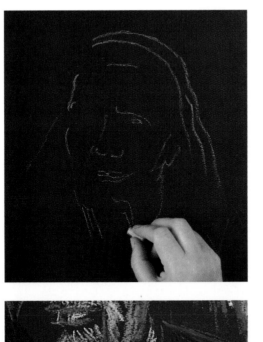

2 *The main areas of contrasting light and dark tones are drawn with short strokes of Burnt Sienna, Yellow Ocher, gray, Vandyke Brown, and white.*

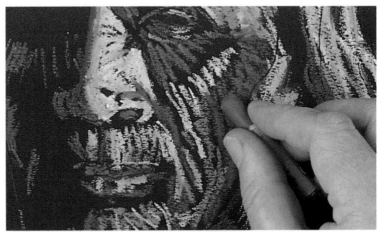

3 *The sari is drawn with Prussian Blue and dark gray. Touches of Vandyke Brown lend warmth to the gray. The flat edge of a blade is used to scrape away excess color.*

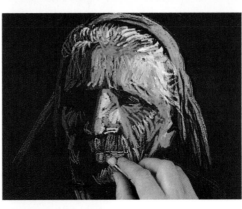

4 *The hair is drawn first with light gray, dark gray, Vandyke Brown, and white, then with strokes of pink, Yellow Ocher, and pale orange. Some areas are scraped back so that more color can be applied.*

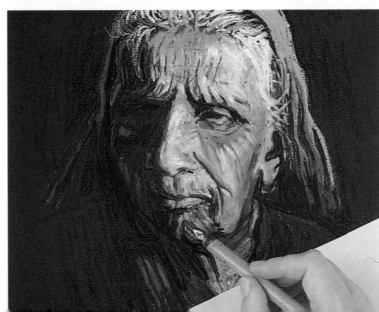

5 *Work now concentrates on the face, building up color on the forehead with short strokes, then scratching through the pigment to reveal the black paper, to denote all the lines and wrinkles. All the tones are now moderated, and the sari is redrawn after scraping away the first drawing. Parts of the drawing are masked with paper when working on small areas of detail.*

Artist • Cecilia Hunkeler

102

1 *The main features of the head are rendered in wax crayon on a dark-toned Canson paper.*

2 *A basic tint of Yellow Ocher is worked into the face, with the exception of the eye sockets and mouth. Short strokes of pale gray describe the hair uncovered by the veil.*

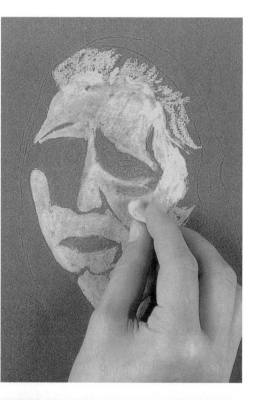

3 *Black, Prussian Blue, and viridian chalks are fused together to create a dark tone for the dress. Black is also added to the shadows created by the sitter's veil. The veil itself is drawn in a light brown blended with dark gray, which in turn is softened with a wet brush.*

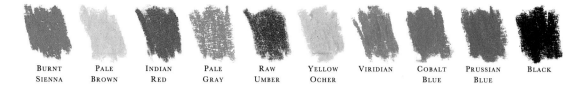

| BURNT SIENNA | PALE BROWN | INDIAN RED | PALE GRAY | RAW UMBER | YELLOW OCHER | VIRIDIAN | COBALT BLUE | PRUSSIAN BLUE | BLACK |

4 *The modeling of the face is now developed in contrasting warm tints of Burnt Sienna, Indian Red, Yellow Ocher, Raw Umber, and white. The sleeves and folds of the dress are defined with black chalk.*

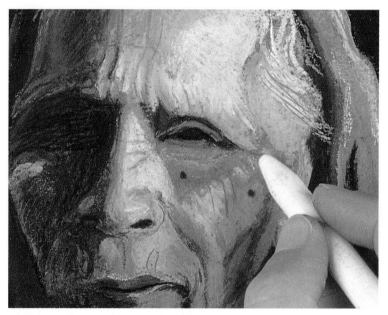

5 *A background tone of black chalk used at full strength is applied to provide contrast and to make the color in the face appear more concentrated. A white chalk is burnished into the lighter planes of the forehead, nose, and cheekbone.*

6 *All the tints are now blended with a torchon. Details such as creases and folds of skin are heightened with a black wax pencil. Finally, all the tones are carefully modulated from light to dark.*

Artist • Sophie Mason

104

1 *The main contours of the face are lightly drawn on white cartridge paper with pencil, and Burnt Umber and black pastel pencils.*

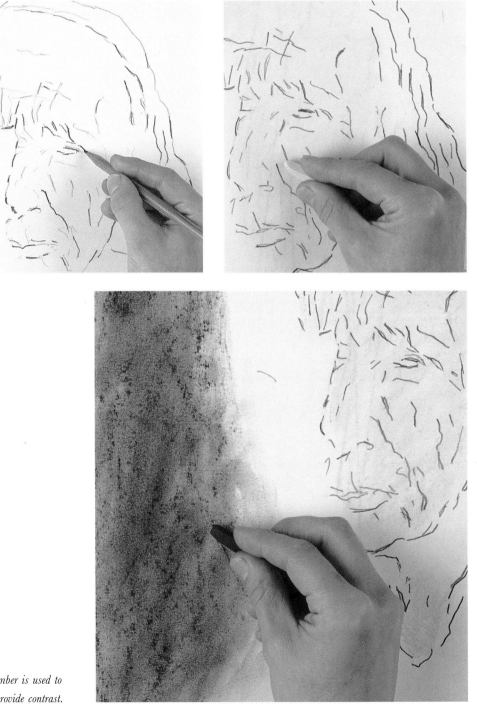

2 *A pale tint of Naples Yellow is spread over the face as a background tone for the colors to follow.*

3 *The flat side of a stick of Raw Umber is used to create a dark background tone and to provide contrast.*

| INDIAN RED | NAPLES YELLOW | YELLOW OCHER | MARS VIOLET LIGHT | PERMANENT RED | RAW SIENNA LIGHT | BURNT UMBER | COBALT BLUE | PRUSSIAN BLUE | BLACK |

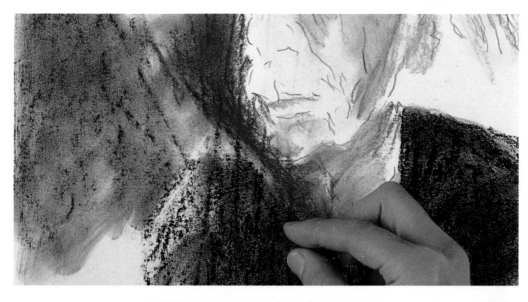

4 *The flat side of a stick of Prussian Blue is used to spread a tint over the woman's clothing. Raw Sienna is added to highlight those areas of the face that are turned towards the light. A Permanent Red is used on the ear, chin, and neck and carried through to other areas. Indian Red and Burnt Umber are blended on the left side of the face to suggest shadow and recession. A mauve violet is added to the scarf.*

5 *Yellow Ocher is introduced on the right side of the face to make it darker in tone. Burnt Umber pastel and a black pencil are used to define creases and lines in the face and to provide more definition generally.*

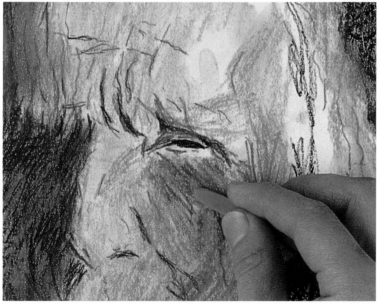

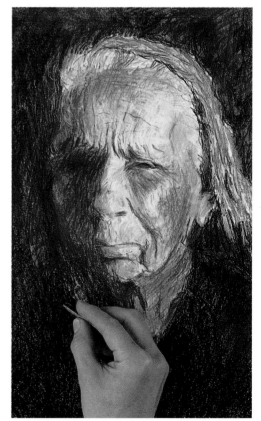

6 *The drawing is brought to a conclusion with a great deal of linear work using pastels and pastel pencils – mainly Burnt Umber, Raw Umber, black, and touches of Cobalt Blue.*

Portrait • *Critique*

Linear treatment works well

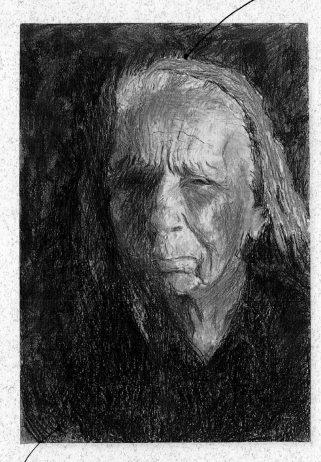

Subtle handling of dark tones

HELEN This is a good example of the way that an impasto technique can be used effectively. Layers of color have been built up, scraped down, and redrawn, lending an almost sculptural quality to the drawing. A dark, near-black background always compresses color values, but it is important to get the balance right. Here I feel that the cotton sari could have been a shade lighter in relation to the dark background

Good example of impasto technique

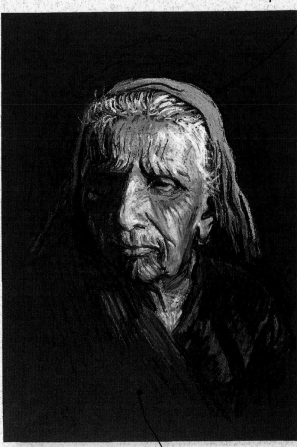

The cotton sari is too dark and too opaque

SOPHIE This was a difficult subject to translate in terms of the medium because of the strongly contrasting tones. The artist has overcome this to some extent by treating everything in a strictly linear way, so that tones accrue in a cumulative web of thin pastel strokes. When seen from a distance, everything in the drawing seems to jell together. The darker tones of the left-hand side of the drawing are handled with subtlety. When building up a drawing in this way it is important not to lose sight of the main forms, which can be lost under the weight of too much pigment.

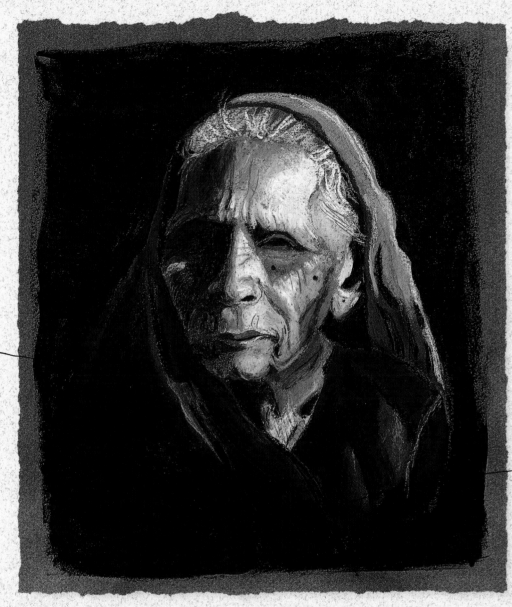

careful use
of a restricted
palette to
model the form

surface
pigment
too heavy
in some
places

CECILIA The commanding presence of the subject comes
across in this drawing. By deliberately limiting both color and tone,
the artist has been better able to control the modeling of the
form. She has clearly been fascinated by the wrinkled, folded
flesh of the old lady's face and has tended to exaggerate those
qualities. But the handling of the veil and the woman's sari is per-
haps rather too heavy – the surface pigment could have been
reduced with a soft brush in this instance.

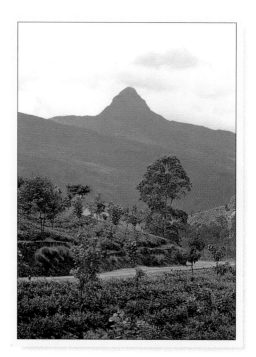

Landscape

TEA PLANTATION

It sometimes happens that objects that are just in front of us are the most difficult to perceive. Landscape is indeterminate; we survey a scene, allowing ourselves to select freely – grouping and composing various elements in the mind's eye. The great challenge of landscape is that it forces us to search much harder to uncover things that we see, but do not always perceive. All artists are faced with the task of rediscovering the landscape through their own stream of consciousness. To do this we need to have a sense of scale and proportion, rhythm and movement, and a sense of the spatial dimension of landscape, the way that some things advance and others recede.

It is difficult to say why you decide to draw one particular section of a landscape view more than another, but it has something to do with the way that you feel, intuitively, a sense of rightness about the way things are disposed. Usually there is some focal point that holds our attention and lends interest to what might otherwise be a monotonous view. In this instance, a mountain peak punctuates the gentle slopes of a tea plantation.

Working with chalk or oil pastels, one cannot do more than treat everything in terms of color, tone, and texture. It would be futile to try to draw individual leaves or blades of grass when using such a broad medium. However, pastels are easy to carry and useful for making landscape sketches that can be worked up later in the studio.

Landscapes such as this, which are beautiful to behold, are not always suitable subjects for the medium we happen to be working with. Sometimes we make a number of false starts before we discover exactly the right way to interpret a subject. My own feeling is that a good landscape drawing should give the impression that the artist has actually walked through the hills and valleys touching every surface, and this tactile quality should be evident in the final work.

Artist · Helen Armstrong

| BLACK | PRUSSIAN BLUE | COBALT TINT | OCHER TINT | GRAY | CHROME GREEN LIGHT | OLIVE GREEN | CHROME GREEN DEEP | ULTRAMARINE |

1 *The main landscape forms are briefly stated in pencil on a thin, pale green pastel paper. White and a touch of Yellow Ocher are blended together in the sky area with the side of the hand. A thin layer of light Yellow Ocher is added to the mountain.*

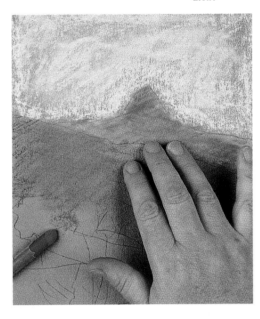

2 *Ultramarine and Prussian Blue are rubbed together with a finger over the mountain slopes. This in turn is moderated with a touch of gray.*

3 *Three greens are used at this stage – Chrome Green Deep, Olive Green, and Chrome Green Light. They are smudged slightly with a finger. All the tones are fairly even at this stage.*

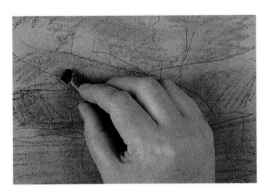

5 *Colors and tones are now unified and the drawing reestablished using Olive Green and black, with touches of Chrome Green Deep. The foreground area is drawn with short, successive strokes of violet, black, and Chrome Green. Tones in the distance and sky are leveled out by more blending with fingers, so that the tonal recession from the foreground to the background becomes more apparent.*

4 *A darker tint of Olive Green is added to the escarpment in the middle distance. More white is added to lighten the sky and hills. Cobalt Blue, Chrome Green Deep, and Prussian Blue are blended together to create an atmospheric effect over the hills.*

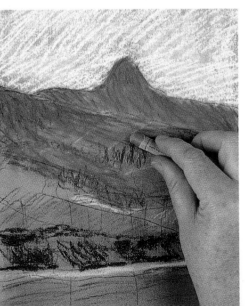

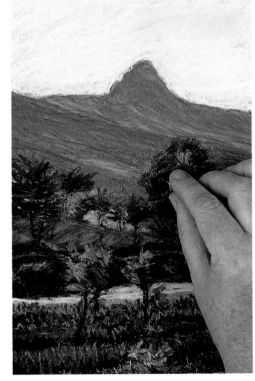

Artist • Cecilia Hunkeler

110

1 *The outlines of hills, trees, and basic landscape forms are lightly drawn with a green wax crayon on pale gray Canson paper.*

2 *Neutral tints of gray, pink, Yellow Ocher, and a pale green are fused into the sky area and the path in the foreground. This is reduced with a brush and water to produce a wash-like effect.*

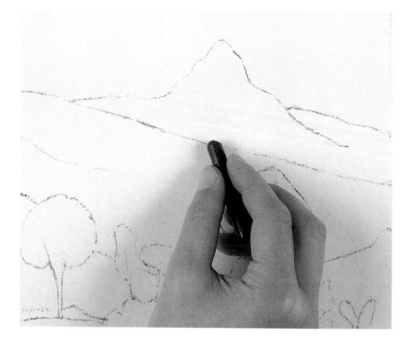

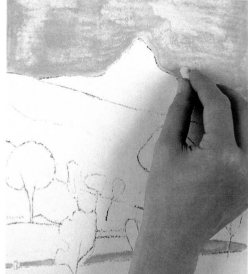

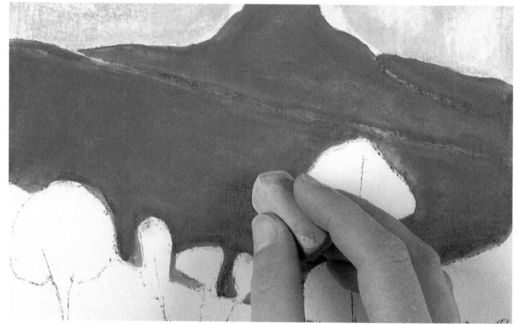

3 *A turquoise blue is worked into the slope of the hills and distant mountain. The color is then moderated with a tint of gray.*

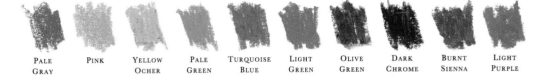

| PALE GRAY | PINK | YELLOW OCHER | PALE GREEN | TURQUOISE BLUE | LIGHT GREEN | OLIVE GREEN | DARK CHROME GREEN | BURNT SIENNA | LIGHT PURPLE |

④ *Pale Green, Light Green, Chrome Green, and olive are drawn into the basic shapes of trees, the plantation, and foreground area of vegetation. A darker tone of Burnt Sienna is added to the steep bank alongside the path.*

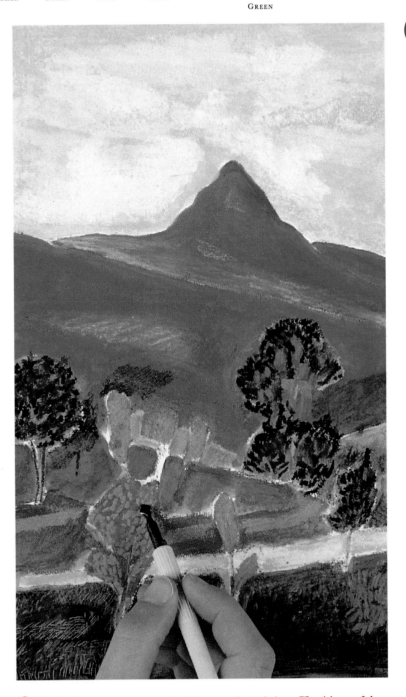

⑤ *An intense green is rendered in short strokes to suggest the luxuriant foliage. The mountain slope is made lighter in tone with white chalk, and more intense color is fused into the foreground.*

⑥ *Leaf and grass textures are rendered by a scraping technique. The richness of the vegetation is intensified and darker tones added to the trees.*

Artist • Sophie Mason

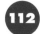

1 *A tinted pale gray Ingres paper was selected in relation to the subtle tones required for the interpretation of this subject. A preliminary drawing is made sparingly with a pencil.*

2 *Touches of lilac pastel are added to the mountains to suggest distance.*

3 *Hooker's Green is selected to suggest the main trees in the middle distance. More lilac is added to the background.*

| NAPLES YELLOW | OLIVE GREEN LIGHT | MARS VIOLET LIGHT | PERMANENT RED LIGHT | LILAC | VIOLET | HOOKER'S GREEN | BURNT UMBER | 4B PENCIL |

4 *White and Permanent Red are roughly drawn into the sky and blended with a finger to produce a pale pink hue. Brilliant and mid-green are used for the vegetation in the foreground, and a touch of Mars Violet lines the road.*

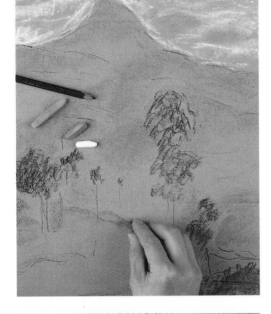

6 *A violet pastel is again used to provide more definition for the vegetation in the foreground. A pale olive tint is introduced to provide contrast with the vegetation. More violet is added to the background using a layering technique.*

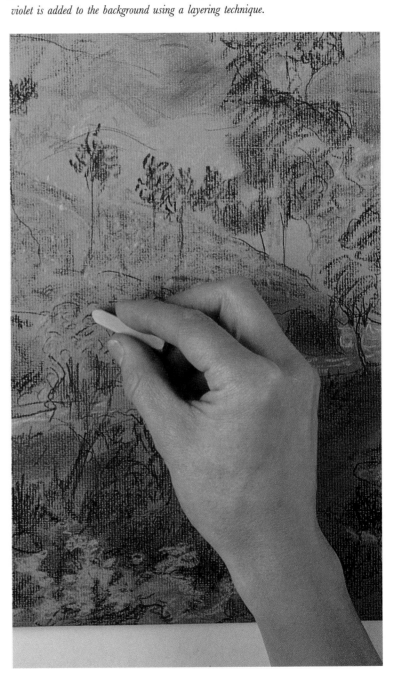

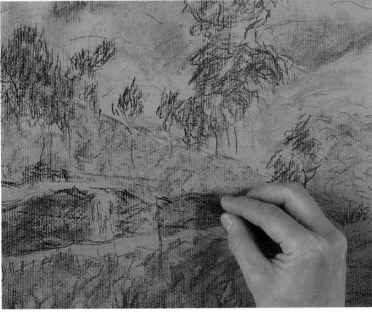

5 *More Hooker's Green is used to define the shape of the trees. Burnt Umber provides a darker tone for the bank and shadow above the road. A violet pastel provides some shadow on the mountains, and Naples Yellow is added to the sky.*

Landscape • *Critique*

selected color scheme relates well to subject

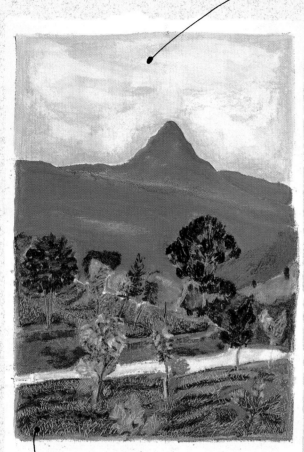

scraping technique overworked in foreground

SOPHIE This is a good example of how careful composition can enable an artist to harness and control predominantly horizontal landscape forms within a vertical format. There is a good feeling for light and atmosphere, although I feel that some colors could have been worked with greater density. The flat side of the chalk rather than the tip can be used to suggest broad shapes of foliage and other natural forms.

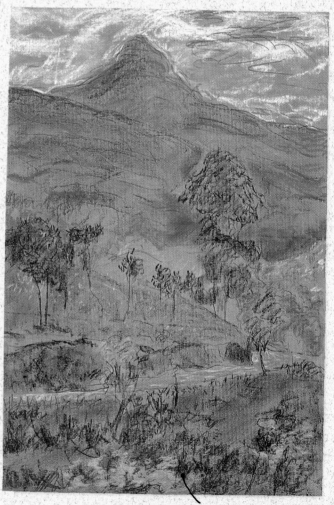

CECILIA The colors selected for interpreting this subject leave us in no doubt that this landscape lies somewhere in the southern hemisphere. There are echoes of Paul Gauguin's South Sea paintings in the way that everything has been simplified into basic shapes. My only criticism concerns the scraping technique, which I feel has been overdone in the foreground and, for this reason, I prefer the drawing when it is seen at the previous stage. Generally speaking, one needs to think about producing contrast by using strong textures over, or adjacent to, flat areas of color.

more tonal contrast required to suggest distance

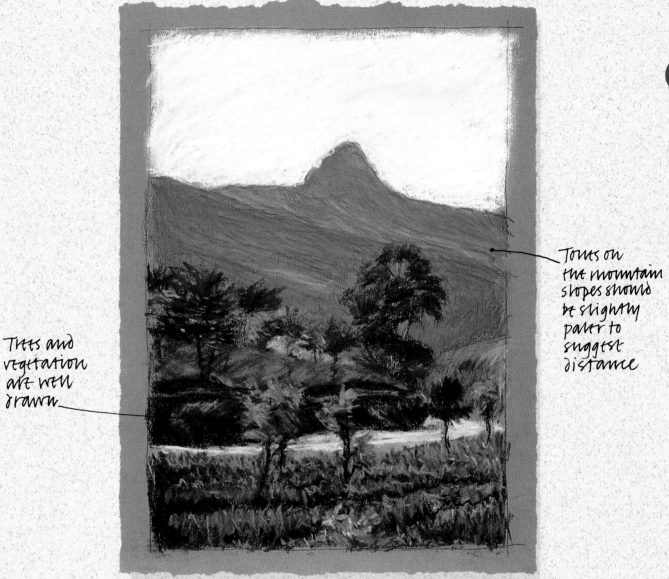

Tones on
the mountain
slopes should
be slightly
paler to
suggest
distance

Trees and
vegetation
are well
drawn

HELEN There is nothing fussy about this drawing; one feels that every mark is intended to contribute to the overall statement. The tones in the middle distance and foreground have been handled well in terms of technique and visual judgement. All the vines, trees, and vegetation have been drawn with conviction. From a compositional standpoint, some might feel that everything is too evenly balanced, and that the foreground might have been extended. Although the white, featureless sky serves to define the shape of the mountains, I feel that just a hint of a warm hue might have enhanced the drawing in relation to the subject.

Animal Study

THE GUINEA PIG

always find it more interesting to draw a portrait when the sitter's attention is fully engaged by some personal interest – reading, sewing, or cooking, for instance – or, as in this case, comforting a pet animal. There is a greater sense of intimacy, as if one is invited into the private world of the sitter, and this, it seems to me, is infinitely better than having that same person posing uneasily in an upright chair, staring blankly into space. The work of Pierre Bonnard and Edouard Vuillard, for example, is full of such intimate expressions of everyday domestic life. Bonnard, I feel, was trying to produce drawings and paintings that impressed not so much by their strength but by their very fragility, and the overwhelming tenderness he felt for his subjects is imprinted in the delicate lines of his drawing and brushmarks.

The tenderness shown by the young girl towards her guinea pig is, perhaps, the most important aspect to bring out in the drawing. Additionally, you are confronted by the task of dealing with a variety of different textural qualities – the coarse, short hair of the animal against the girl's smooth complexion and long, fine strands of hair. Tonal contrasts are soft rather than harsh, and this suggests the need for blended color. In my view, one should aim for understatement in order to render the sensitivity and delicacy that the subject calls for.

Either chalk or oil pastels could be used, or a combination of both. It is a subject that tests the artist's ability to control the medium in terms of color, tone, and the representation of very different tactile qualities.

Artist · Helen Armstrong

PRUSSIAN BLUE · RED VIOLET DEEP · GRAY · YELLOW OCHER · CARMINE

117

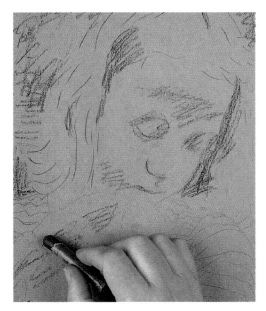

① *Outlines are drawn tentatively with a pencil on a thin, light gray pastel paper. Tones are suggested with a few strokes of Burnt Umber.*

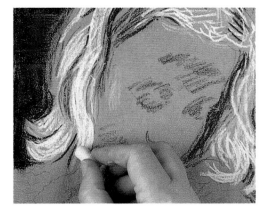

② *Olive Green, Chrome Green, black, and gray are blended together to produce an intense green-black background. The pale color of the hair is produced with strokes of pale Sienna and light Yellow Ocher – adding flecks of Burnt Sienna, Yellow Ocher, and Olive Green and allowing the gray paper to show through.*

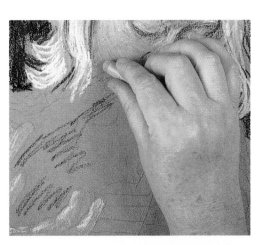

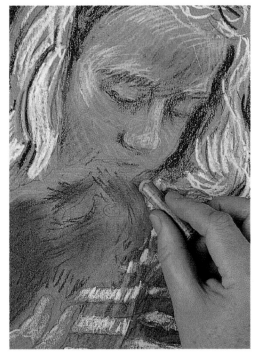

④ *The blue stripes of the shirt are drawn with Prussian Blue, which is modified by using gray on top. The white stripes are softened by a touch of Cobalt Blue blended with white. A ground color for the guinea pig is made up of Burnt Sienna, Yellow Ocher, and Burnt Umber, which are blended with a finger.*

③ *The face and hands are drawn with a feathering technique with alternate strokes of pale Yellow Ocher, Gold Ocher, pale Burnt Sienna, and carmine for the skin colors. Touches of pale mauve are added to eyelids, and Olive Green and Burnt Umber around the eye sockets.*

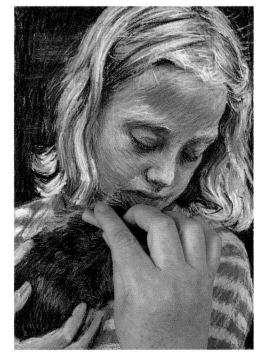

⑤ *The whole drawing is now given much greater definition – especially on the face, hair, shirt, and the guinea pig, using short, rapid strokes, and working the colors together. The fur of the guinea pig is darkened with black and Olive Green as well as light and dark browns, and Gold Ocher is used for the head.*

 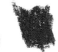

GOLD OCHER · OLIVE GREEN · BURNT UMBER · BURNT SIENNA · DARK CHROME GREEN · ULTRAMARINE DEEP

Artist • Cecilia Hunkeler

1 *The main outlines are drawn with a blue wax crayon onto blue-gray Canson paper.*

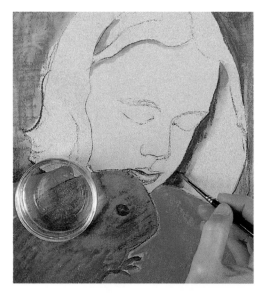

2 *Burnt Sienna and Burnt Umber are worked into the background, and reduced to a semi-transparent tone with a brush loaded with water. A flesh tint is applied thinly over the face, and a tint of Cobalt Blue drawn into the shape of the shirt. Basic tones of Raw Sienna and Burnt Umber are blended at full strength to indicate the fur of the animal.*

3 *White chalk is roughly scribbled over the hair, and on highlights on the sitter's face, such as the cheekbones and nose.*

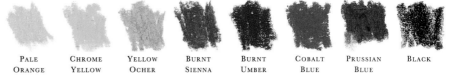

4 *A pale tint of Chrome Yellow and a darker hue of Yellow Ocher are blended in the girl's hair and on the forehead and cheekbones. The tone of the animal's fur is lightened with ocher, and the texture suggested by a scraping technique.*

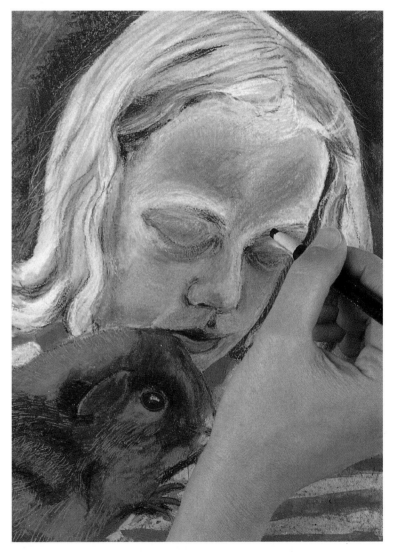

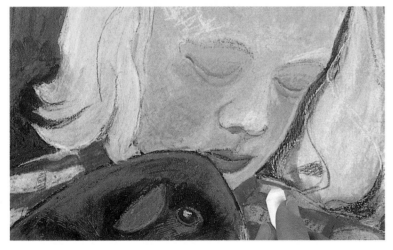

5 *Warmer flesh tints are blended on the girl's face. The hair is made lighter by overworking the yellow with white chalk. The white stripes are picked out on the skirt, and a darker tone of brown added to the animal.*

6 *All the colors and tones are now finely modulated in relation to each other. A black chinagraph pencil is used to define details on the girl's hair and face, and on the animal. More lines are scraped out to suggest the coarse texture of the animal fur.*

Artist • Sophie Mason

120

1 *A preliminary pencil drawing is made on a cream-colored cartridge paper, with additional strokes in Burnt Sienna and Yellow Ocher pastel pencils.*

2 *Using the flat side of a stick of Yellow Ocher, a broad tint is laid and spread with fingers to achieve a base color for the head.*

3 *Burnt Umber is used both for the guinea pig and for darker tones on the girl's face.*

VIOLET DARK	NAPLES YELLOW	PALE COBALT BLUE	TURQUOISE	BURNT SIENNA	BURNT UMBER	DARK GRAY	CADMIUM RED	YELLOW OCHER	BLACK

4 *A gray pastel is introduced to indicate very freely the striped pattern of the girl's shirt. Black pastel is smudged over the background to create tonal contrast. A touch of red is added to the mouth.*

5 *Violet Dark is used in short strokes for the hair on the guinea pig, and also on the girl's hair. Some drawing is done in pencil to redefine the shape of the girl's face. A green-gold is introduced on the hair, as well as touches of Yellow Ocher and Burnt Sienna, using pastel pencils.*

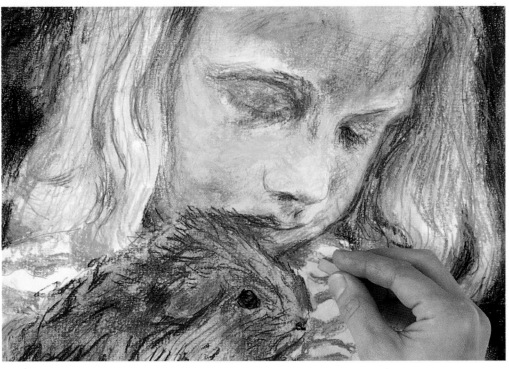

6 *Blues are blended into the background, and more black and Raw Umber added to provide richness of color and contrast. More definition is given to the face, and some areas are brought out and highlighted by Naples Yellow. Pale blue is drawn over the gray on the stripes of the shirt.*

Animal Study · *Critique*

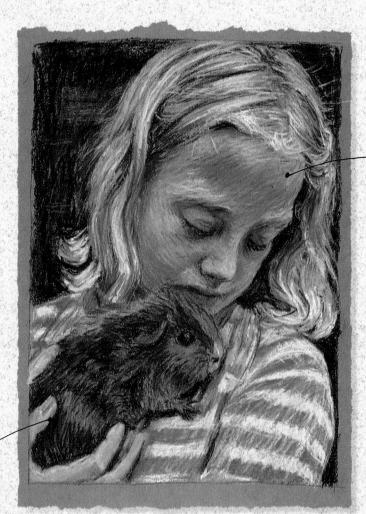

A skilful treatment of varied textural qualities

Girl's hands are awkwardly placed

HELEN There are a lot of subtleties in this drawing, which may not be immediately apparent (or may be lost in reproduction). Notice, for instance, how the artist has managed to convey the softness of the girl's hair and complexion by a careful blending of warm and cool hues of chalk pastels. Notice, too, how a feathering technique has been used to render the modeling of the girl's features. Again, the treatment of the animal has been arrived at by careful analysis of the color and textures. My only reservation lies in the way that the girl's hands are awkwardly placed in terms of the overall composition of the drawing.

Background tone is too level in relation to other tones

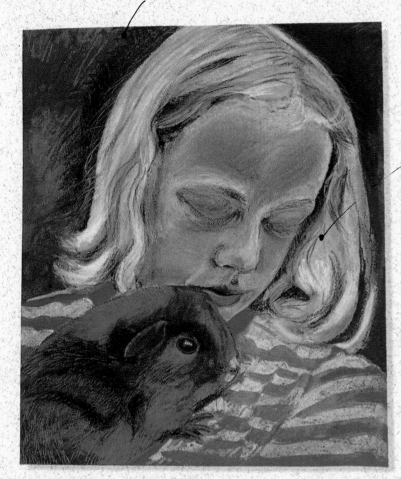

could have been more contrast in the folds of the hair

SOPHIE From the outset, the artist made the decision to get as close to the model as possible by focusing on the expressive qualities that are the essence of this subject. All extraneous detail has been eliminated, including the awkwardness of the hands. Notice how this drawing is built up from a few closely related warm colors. The strong linear quality is achieved by using sharpened pastel pencils.

All extraneous detail has been eliminated

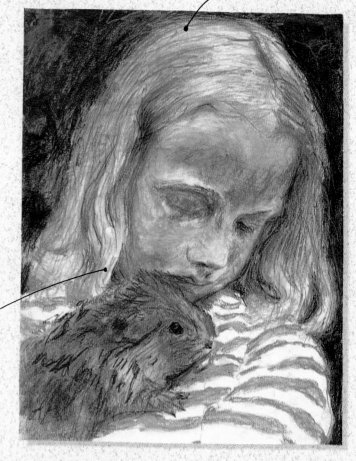

Expressive qualities emphasized

CECILIA The overriding sentiment and pathos of the subject have been handled in a sympathetic way. The artist has also successfully employed a variety of pastel techniques to convey the range of textural qualities. The fur of the animal, for example, has been drawn with a scraping tool, which scrapes a linear texture in the top layer of color, revealing the lighter base color. The background tone, in my view, could have been a shade darker.

Townscape

A WINDOW IN NAPLES

In almost any town or city in Italy in the course of a single day, the population, young and old, acts out scenes that convey joy, despair, hope, fear, anger, and disappointment to the observer. The street life becomes the backdrop for an alfresco opera in which everyone plays a leading part. Family ties remain strong even in the most impoverished conditions. Children, in particular, hold a special place in Italian life. No Italian street scene would be complete without a few children in it.

There is a sense of the theater in this view of a tenement in Naples. The window in this street scene is rather like an old picture frame: the crumbling moldings and stucco with open shutters serve to isolate the diminutive figures of the two children. Both children seem bored, waiting for something to stir their interest. Compositionally, it presents an interesting subject, and, in terms of color, the somber hues of the building are relieved only by the pale carmine red of the girl's dress.

You might begin drawing with a base tint of Raw Sienna, perhaps dilute oil paint or gouache. Layers of chalk pastel of the same hue might be needed to suggest the texture of the stucco. The architectural detail could be rendered with pastel pencils or sepia ink, and a broad reed pen. Alternatively, you could use oil pastels throughout to produce a soft, unfocused drawing.

Artist · Helen Armstrong

BURNT UMBER	BURNT SIENNA	OLIVE GREEN	GRAY	PERMANENT RED LIGHT	GOLD OCHER	LEMON YELLOW	CARMINE	MADDER LAKE DEEP

125

1 *The main outlines are drawn in pencil on a beige Fabriano paper. Base tints of light yellow, Yellow Ocher, Burnt Sienna, Lemon Yellow, and deep yellow are blended with tissue into the paper's grain.*

2 *The shadows are indicated with Burnt Umber rubbed in with tissue.*

3 *Lighter tones are overlaid on the top ledges of window frames and walls to suggest the chalky texture of the crumbling stucco. Colors used at this stage are lemon yellow, Yellow Ocher, and Gold Ocher.*

5 *The tone of the stucco is made lighter at this stage by using a light yellow. Details are generally given a sharper definition and shadows made more intense. Burnt Umber and Olive Green are used to suggest stains on the stucco walls. Finally, the artist uses short strokes of Yellow Ocher to level out the tones of the façade.*

4 *Carmine and Madder Lake are used for the girl's dress, and Gold Ocher and pale Burnt Sienna for flesh tones. Black and dark brown are used for deeper shadows and for heightening details. Color is burnished with a finger to indicate the stucco walls.*

Artist • Cecilia Hunkeler

126

1 *The windows, shutters, and the outlines of the main architectural detail are drawn in red crayon onto pale gray Canson paper.*

2 *A base color of Yellow Ocher is painted in gouache over most of the wall surface. This in turn is overlaid with patches of white, Yellow Ocher, and Raw Umber oil pastels. The shutter and darker recesses are painted in Burnt Sienna gouache.*

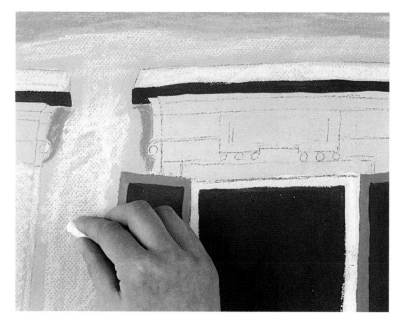

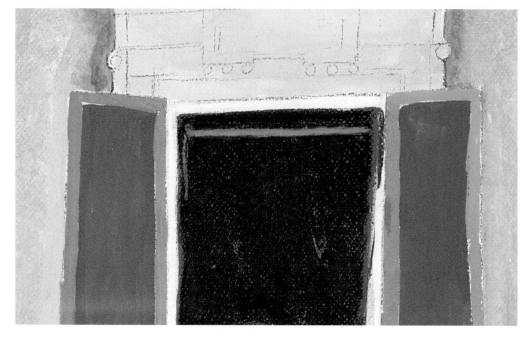

3 *The overall tone of the wall surface is made lighter by blending white chalk into the existing yellowish color.*

ROSE MADDER VERMILION YELLOW OCHER RAW UMBER BURNT SIENNA VANDYKE BROWN BLACK

127

4 Vandyke Brown oil pastel is drawn through a gauze mesh to add texture to the tone behind the children at the window. The same tone is added to the underside of ledges and cornices. The shape of the girl's dress is drawn in a tint of Rose Madder.

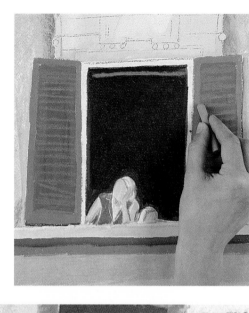

6 In the final stage, the patterns on decorative moldings above the windows are scraped out of existing color, and more colors are blended into the surface. The top window is redrawn and details such as the struts of the shutters are more precisely defined. Finally, more color is worked, burnished, and scraped on the wall surface to produce a stucco effect.

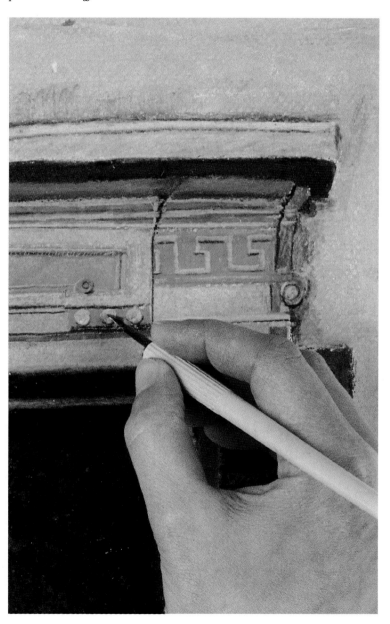

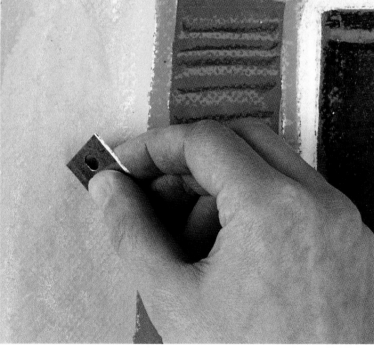

5 More tints of light and dark ocher are added to the wall surface and then scraped and reworked, to represent the texture caused by weathering and decay. A Burnt Sienna oil pastel is worked into the window recess behind the children to make it less dark.

Artist • Sophie Mason

128

① *A warm, light brown paper was selected in relation to the overall color scheme. The main lines of the building – lintels, shutters, and window – are drawn in with a Brown Umber pastel pencil.*

② *The lightest tone on the stucco is drawn with a Naples Yellow crayon (water-soluble).*

③ *Yellow Ocher and Raw Sienna are roughly blended with a finger over the main area of the building.*

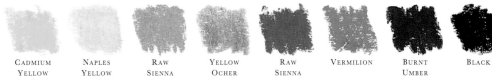

4 *The shutters are drawn with Burnt Umber, and the same color is used for areas of shadow. The dark recess of the window is drawn in black, isolating the figures of the children.*

5 *Some variety is given to the texture of the wall with pale Cadmium Yellow, which is blended with colors applied previously. Black and Burnt Umber are used to provide more definition. Touches of Permanent Red Light and ocher are used to highlight the children's faces and arms.*

6 *Vermilion is used on the girl's dress. Most of the work in the final stage is expended on the texture of the wall. The slats of the shutters are carefully drawn using a Violet Dark crayon. Finally, part of the color is softened with a brush and water.*

Townscape • *Critique*

130

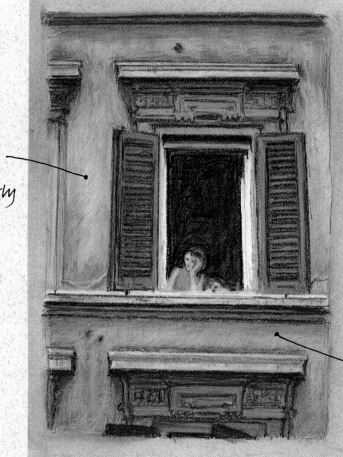

The freshness of the early stages slightly lost in the final stage

Balance between color, tonal values, and descriptive detail is successfully achieved

HELEN The early stages of this project worked well when the color was softly rubbed in. The freshness of these early stages was slightly lost when architectural detail was superimposed. Nevertheless, the texture of the crumbling stucco has been handled well. The darkest tone ought to be the recess of the room seen through the open window. Otherwise, the tonal balance is about right.

Because pastels are opaque, one can easily work and blend pale colors over dark and sometimes allow parts of a dark ground color to show through and enrich the drawing.

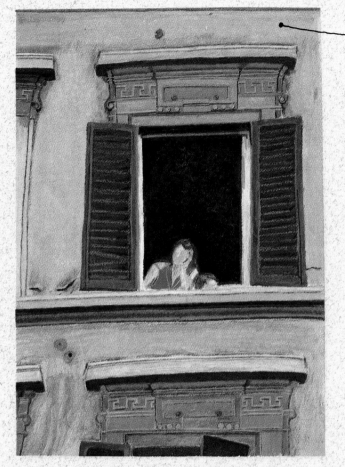

convincing rendering of the surface qualities of decaying stuccos

SOPHIE Everything is understated in this drawing. I feel that more attention could have been given to architectural detail, and to contrasting color and tone. In other words, more resolution is required to invest the drawing with interest. As it stands, the drawing looks like a detail from a much larger study. Perhaps the artist might have derived more interest from the subject by moving closer to the window, or, conversely, by viewing the subject from a greater distance.

More attention to architectural detail needed

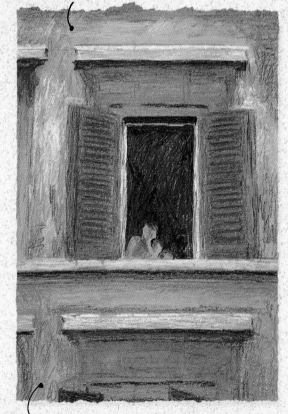

Judicious use of mixed media

CECILIA The artist has enjoyed the challenge of trying to produce a convincing drawing of the surface qualities of decaying stucco. The scraping technique is particularly effective in this instance, conveying the illusion of recessed patterns in the moldings above the windows. When working with a scraping technique for oil pastels, it is a good idea to work to a larger scale, in order to be able to exercise more control. Chalk and oil pastels have been successfully combined to produce a bas-relief effect.

The drawing of the children is carefully understated in relation to the wealth of surrounding texture. This is a good example of the way that materials can be harnessed to serve the intentions of the artist.

Seascape

FISHING JETTY

In the half-light of dawn or dusk, the main features in a landscape are reduced to silhouettes, and everything appears to be abstracted to a basic, two-dimensional pattern. At sunrise or sunset there is a scattering of light caused by the molecules of air, and the presence of dust and moisture in the atmosphere. Because the overall illumination is less intense, and the quality of light more even, the contrast between light and dark areas is much softer. The tonal scale is therefore easier to define.

In this scene of fishermen off the coast of Malaysia, the wooden jetty acts as a visual device that leads the eye from one side of the composition to the other. The continuous horizontal rhythm of the composition is interrupted only by the standing figure of one of the fishermen. It is a subject that calls for restraint, and a careful balance between softly blended nuances of color and tone, overlaid by a sharply defined silhouette that will hold everything together.

The versatility of the pastel medium becomes more apparent when dealing with subjects such as this, especially when chalk and oil pastels are combined to suggest how sea can appear both opaque and translucent, while still reflecting the hues of the sky.

Artist · Helen Armstrong

| BLACK | PRUSSIAN BLUE | ULTRAMARINE DEEP | ULTRAMARINE TINT | BLUE VIOLET | COBALT BLUE | RED VIOLET DEEP | YELLOW OCHER TINT |

1 The basic outlines of the composition are drawn in pencil on a Fabriano "duck egg" blue paper.

2 The flat side of a mid-toned blue is wiped across the area of the sky and sea. The pigment is then rubbed with a soft tissue on the sky, and on the reflections on the water.

3 Successive strokes of mauve, cream, and white are blended with tissue to lighten the sky. Lighter tints are also added on the smooth sea around the wooden jetty. Prussian Blue is blended into the sea and sky on the left-hand side of the composition. Cobalt Blue suggests reflected light beneath the jetty.

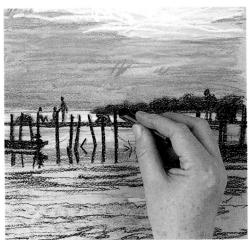

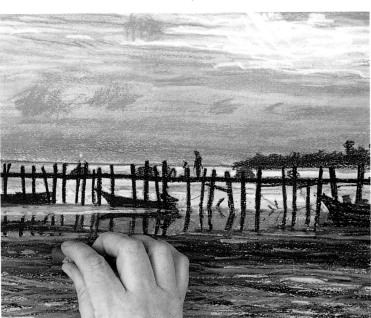

4 The horizon is redefined with Prussian Blue and this is carried through to other parts of the drawing, including the land, jetty, and boats. Black is worked over the blue on the jetty, and the boats and reflections are drawn in ultramarine with a touch of black.

5 The tone of the water in the foreground is made much darker with Cobalt Blue, violet, and black. A light blue is overlaid between the jetty posts to suggest waves in the sea. A diminutive spot of mauve picks up the lighthouse light. The black on the jetty is moderated by overdrawing with ultramarine. Coarser strokes are used in the foreground and partially blended with a finger.

Artist • Cecilia Hunkeler

134

1 *The structure of the wooden jetty, boats, the headland, and clouds are tentatively outlined in a dark blue crayon on a tinted ultramarine Canson paper.*

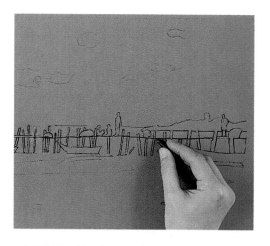

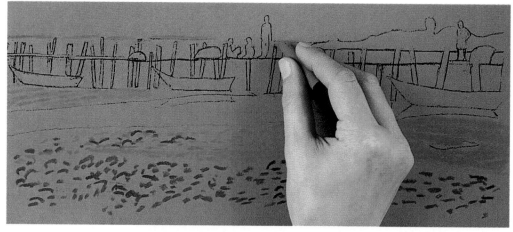

2 *Specks of Prussian Blue and Cobalt Blue are stippled on the sea in the foreground. A paler tint of Cobalt Blue is added above the stippled texture and along the horizon. A touch of violet is introduced to the sea below the jetty on the far left.*

3 *A pale mauve tint is blended into the sky on the right and extended to the sea in spaces defined by the structure of the jetty. The same color is stippled into the sea in the foreground. A darker blue-violet is then drawn into the sky on the left, and immediately reduced to a transparent tint with a wet brush. A pale cobalt tint is also blended into the sea on the left, from the horizon to the jetty.*

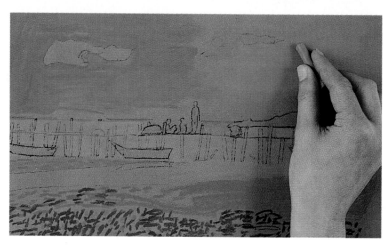

DARK BLUE	COBALT BLUE	PRUSSIAN BLUE	PALE VIOLET	DARK VIOLET	PINK	BLACK

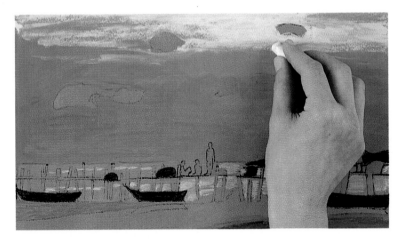

4 *The stippling in the foreground is almost canceled out by a layer of Cobalt Blue. The undulations of the waves are defined with a dark Prussian Blue. Warm hints of red-violet and mauve are added to the sky. A granular chalky blue is laid over part of the white chalk in the top left-hand side of the composition.*

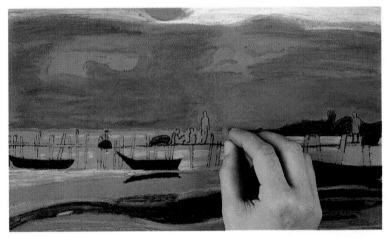

5 *White and pink chalks are blended in the sky in the top half of the composition and then softened with a wet brush. The headland and boats are filled in with black chalk, and a richer oil pastel pigment of Cobalt Blue added to the sea on the right below the jetty.*

6 *The figures standing on the jetty and the structure itself are drawn in black oil pastel. The reflections of the structure are added in the same tone. The waves in the foreground are treated with a variety of textures, including stippling and scraping. The sky, from the horizon to the clouds, is blended to a softer tone. Finally more work is done on the clouds, and to enhance the reflected pattern of light on the sea.*

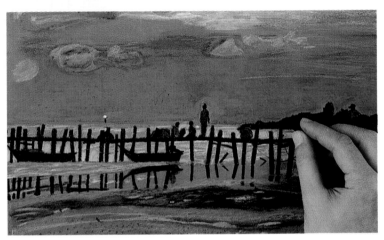

Artist • Sophie Mason

136

1 *The gray-blue Ingres paper was selected in relation to the overall color bias of the subject. The outlines of the jetty in the foreground are drawn with Burnt Umber and Raw Umber pastel pencils. The clouds are suggested with a few pencil strokes.*

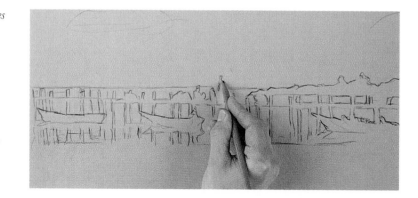

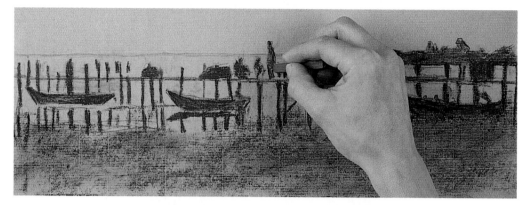

2 *The foreground is roughed in using a Prussian Blue pastel (used on its side). The main structure of the jetty is drawn in Burnt Umber.*

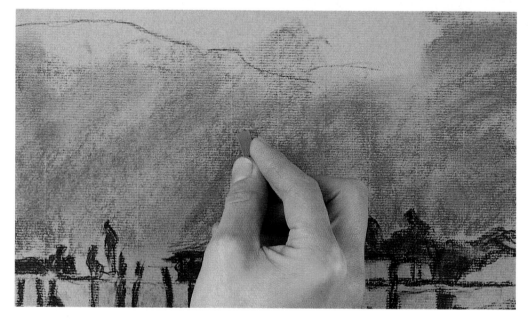

3 *Cobalt Blue and Dark Cobalt Blue are blended together to suggest the mass of sky above the low horizon.*

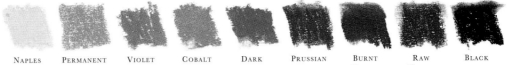

| NAPLES YELLOW | PERMANENT RED LIGHT | VIOLET LIGHT | COBALT BLUE | DARK BLUE | PRUSSIAN BLUE | BURNT UMBER | RAW UMBER | BLACK |

4 *A tint of Permanent Red Light is used to lend emphasis to the shapes of the boats, and around the structure of the jetty. A tint of pink is added to the sky, producing a contrast between warm and cool hues.*

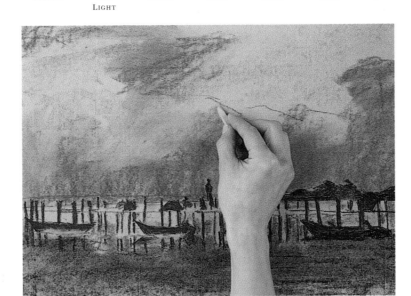

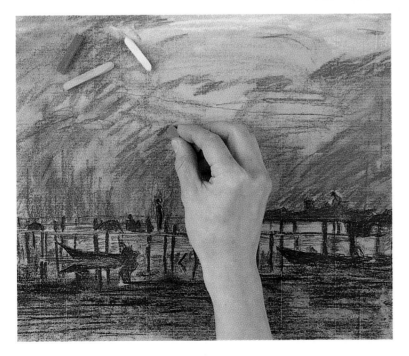

5 *Short strokes of violet are introduced to the sky near the horizon. Naples Yellow is used to lighten certain areas in the picture, and more Cobalt Blue is added to water and sky.*

6 *The depth and detail are brought to the fore using ultramarine and Prussian Blue pastel pencils. Burnt Umber and black pencils are also used to darken some areas, and to intensify the tones of boats and fishermen. Finally, more Permanent Red Light and violet are blended into the sky.*

Fishing Scene • *Critique*

Sky and sea handled well in terms of the medium

HELEN The treatment of the sky and water has been executed with considerable skill, and with an astute awareness of the capabilities of the medium. Silhouettes are notoriously difficult to deal with: if, on the one hand, they are too sharply defined, they become too conspicuous; if they are rendered too softly, the identity of the shape is lost. In this drawing, I feel that the artist might have used another medium for the silhouette of the wooden jetty – ink, perhaps, or even oil pastel diluted with white spirit and applied with a brush.

Good feeling for light and atmosphere

composition is too symmetrical – the structure of the jetty lacks conviction

SOPHIE The artist has deliberately set the horizon line low in the composition in order to concentrate on the sky. The blending of warm and cool hues, and the descriptive, free-ranging strokes help to invest the drawing with interest.

The jetty itself is perhaps too brown, but the overall feeling for light and atmosphere is handled well in terms of the medium. Notice how the base tint of the pastel paper has been incorporated into the color scheme of the drawing as a whole.

The j... could have dark... in to...

The prevailing mood of the subject has been captured well

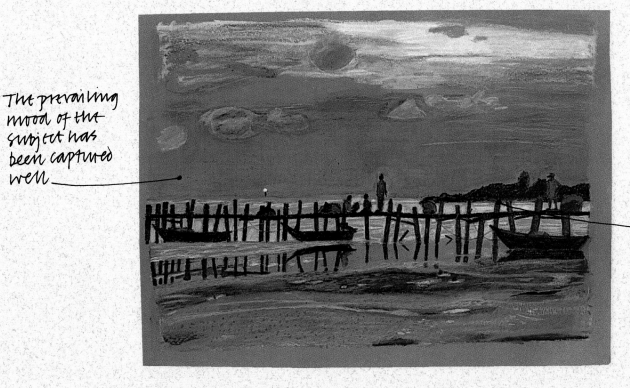

The silhouette of the jetty is slightly too conspicuous

CECILIA The pervading mood of this subject has been captured very well in this drawing, particularly in the way that the light has been controlled. Additionally, the artist has managed to suggest the translucent nature of water convincingly by combining chalk and oil pastels, and then by burnishing, scraping, stippling, and reworking the surface. I particularly like the symbolic quality of the drawing of the upper part of the sky.

The silhouette of the jetty, boats, and figures are perhaps a fraction too conspicuous – this might have been resolved by blending in a touch of indigo or Prussian Blue. The actual rendering of the jetty structure could have been done with more conviction.

Glossary

140

A

AERIAL PERSPECTIVE
Also called atmospheric perspective; the suggested recession in landscape subjects, achieved by taking account of the fact that tones appear to be reduced by atmosphere as they recede in the distance.

B

BINDER
The ingredient used in the manufacture of paints and pastels that holds the materials together, and helps them adhere to paper, board, or canvas.

BLENDING
Merging or fusing together two or more colors using a brush, torchon, or finger.

BODY COLOR
An opaque paint, such as gouache or watercolor, that has been mixed with opaque white gouache.

BURNISH
(a) To rub colors together with your fingers or a torchon to produce a glossy surface luster; (b) To take an impression from a woodblock, linotype, or monotype by continuous rotational rubbing movements with a spoon or brayer (special burnishing tool) on the back of printing paper.

C

CHARCOAL
Sticks of charred willow or vine used as a drawing medium.

COLOR WHEEL
Twelve distinct colors – primary, secondary, and tertiary – arranged in equal progression around a circle.

COMPLEMENTARY COLORS
Complementary colors are found opposite from each other on the color wheel. A color is complementary to the one with which it contrasts most strongly, such as red with green.

COMPOSITION
The satisfactory disposition of all the related elements in a drawing or painting.

CONTÉ
A very hard crayon named after the eighteenth century scientist who invented it, Nicholas-Joseph Conté (1755–1805).

E

ESSENCE
An essential oil extracted from plants or animal substances; an example is lavender oil, which can be used as a solvent for oil paints and oil pastels.

F

FEATHERING
A pastel technique that involves using light, rapid strokes that have a kinetic effect on the drawing, imbuing it with a sense of movement.

FILLER
Usually, white pigment that is added to paints and pastels to extend the range of colored tints.

FIXATIVE
A thin, transparent varnish sprayed onto the surface of a drawing (in pencil, charcoal, or chalk pastel) to make it stable; that is, to stop the pigment from falling off the support. It also prevents smudging.

FORM
The three-dimensional appearance of a shape in drawing or painting.

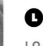

FUGITIVE

A term used to describe colors that are liable to fade under strong light, or in the course of time.

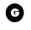

GOUACHE

An opaque form of watercolor combining colored pigments and white filler, and bound in gum. See body color.

GROUND

The first color laid on the surface as a preliminary tone.

GUM ARABIC

In its purest form, the sap produced by acacia trees, used as a binding medium in pastels and watercolors.

H

HUE

The color, rather than the tone, of a pigment or object.

I

IMPASTO

A heavy, paste-like application of paint or oil pastel, which produces a dominant texture.

L

LOCAL COLOR

The actual color of an object, such as the red of an apple, rather than the color the object appears when it is modified by light or shadow.

M

MEDIUM

(a) The type of material used to produce a drawing or painting, e.g., charcoal, pastel, watercolor, oil, etc.; (b) a substance blended with paint to thicken, thin, or dry the paint.

MERGING

The blending of two or more colors gradually so that there are subtle gradations from one hue to another without conspicuous seams or joins.

MODELING

Expressing the volume and solidity of an object by light and shade.

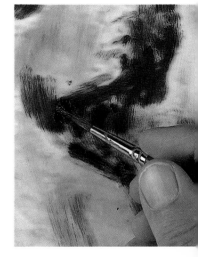

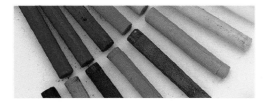

142

MONOCHROME
A painting or drawing produced by a single color, gradations of color, or in black and white.

MONOTYPE
A single print made by painting with oil paint or printer's ink onto a slab of glass, and then transferring the image to paper by burnishing it from the back.

P

PALETTE
The range of colors selected individually by the artist; also refers to the surface on which colors are mixed.

PERSPECTIVE
A means of creating the illusion of three-dimensions when drawing or painting on a two-dimensional surface. Linear perspective makes use of parallel lines that converge on a vanishing point. Aerial perspective suggests distance by the use of tone.

PIGMENT
The colored matter of paint or pastels originally derived from plants, animal, vegetable, and mineral products; generally synthesized chemically in paint manufacture.

S

SCUMBLE
To work a layer of opaque paint or pastel over an existing color in such a way that the

color of the layer beneath is seen through the broken texture of the top layer.

SGRAFFITO
A technique used in oil pastel when the design is scratched through the top layer of color to reveal the lower layer.

STIPPLING
In pastel drawing, a technique of shading using closely spaced dots, or flecks of color.

T

TINT
A color that is lighter in tone than its primary or parent color; usually obtained by adding white, or a diluting agent.

TONE
The light and dark value of a color; for example, pale red is the same tone as pale ocher, but both are lighter in tone than dark brown.

TOOTH
The degree of roughness caused by the raised texture of certain drawing papers, which enables the pastel or charcoal to adhere to the surface.

TORCHON
(Also tortillon or paper stump) A tightly furled stick of soft paper used for blending chalk pastels, pencil, conté, and charcoal.

W

WASH
Dilute color applied to paper to produce an evenly spread, thin, transparent film.

Index

Index